SUBCRITICAL
THIRD CULTURE
FIELD NOTES
Numbered Pages

Edited by **Martha Cary Eppes, Marek Ranis,**

and José L. S. Gámez

Address _____

Phone _____

Project _____

2024
University of North Carolina at Charlotte
Charlotte, NC 28223-0001 USA

US No. 6875507

Book design by Ryan Miller and Marek Ranis
All photographs by Marek Ranis unless otherwise noted

Any opinions, findings, and conclusions or recommendations expressed in this material are those of the
author(s) and do not necessarily reflect the views of the National Science Foundation.

Suggested citation: Eppes, Martha Cary, Marek Ranis, and José L. S. Gámez, eds. *Subcritical: Third Culture Field
Notes*. Charlotte, NC: J. Murrey Atkins Library at UNC Charlotte, 2024.
DOI: https://doi.org/10.5149/9781469679174_Eppes

ISBN 978-1-4696-7916-7 (paperback)
ISBN 978-1-4696-7917-4 (open access ebook)

Published by J. Murrey Atkins Library at UNC Charlotte
Distributed by the University of North Carolina Press
www.uncpress.org

CONTENTS

Foreword: Tectonics of Research in Play

*By **Brook Muller**, Charles Eliot Chair in Ecological Planning, Policy and Design, College of the Atlantic*

In *A Hierarchical Concept of Ecosystems*, authors Robert V. O'Neill, Donald Lee Deangelis, J. B. Waide, and Timothy F. H. Allen present three side-by-side-by-side graphs depicting leaves falling on the forest floor. The saw-toothed lefthand image shows the unpredictable suddenness of autumnal storms blowing leaves off trees, climate events punctuating meteorological lulls. The center image shows the rhythmic recurrence of falling leaves, fall after fall, year after year, a cyclical pattern refreshed in our experience by the budding of trees every spring. The righthand image represents the accumulation of leaf litter over centuries, a progressive model that anyone who has entered churches in Rome or mosques in Cairo can relate to (garbage and debris that has accumulated over many years has raised the levels of streets such that stone steps descend to entranceways six feet below grade).

Through this clever depiction, the authors reveal how what we have to say about dynamic systems, the generalizations we arrive at, depend on our temporal – and spatial – frames of observation. The same holds true for the dynamics of geological systems despite differences in scale and frequency, with deeper and more distant temporal horizons in play. Scientists and artists who work with cracking rocks and who choreograph rigorous practices do so to understand, enrich, and complicate, deploying multiple mediums and devices to connect our thinking and the stories we tell to our embodiment and resilience to the world we inhabit. As we clutch to distressed rocky surfaces in cities and deserts and mountains, as we dance and send drones skyward, our notebooks and magnifying glasses and repetitions enable us to traffic at once in immediacy and remoteness, to regard with heightened intensity the

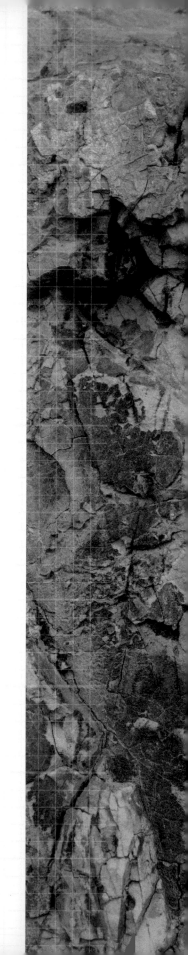

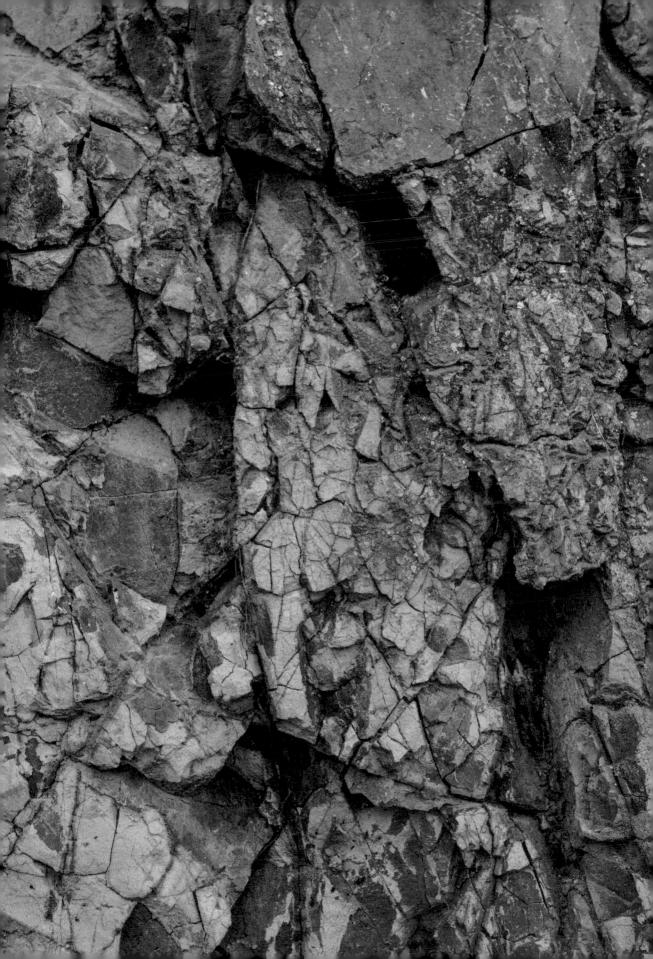

precarity of extreme pressures and the immediateness of fracturing, and the slow change and changelessness of our mineral lives.

This small book explores collaboration and speaks to the value of running creative experiments together and in parallel. We allow comparison and critique by sharing our framings and intermingling our devices, allowing them, and us, to enter into one another's worlds. This work proceeds from respect, openness, and growth-mindedness, the seeking of enrichment and connection to each other and with regard to our collective relationship to this sublime and troubled world.

In *A Wilder Time: Notes from a Geologist at the Edge of the Greenland Ice*, William Glassley, in his temporary remove from humans and immersion in the immensity of rock-and-glacier-scapes, shares his realization: "that we have a place in the world implies responsibility, but it does not signify meaning." The work at play in this volume represents a scrutiny of responsibility, that applying and sharing one's craft, gift, and guild allows us to see our work more freshly, to become unfamiliar once more with our convictions and conventions repeated to the point of forgetfulness. It is to rekindle the uncanny and resituate our work amid a troubled world that does not obey the conventions of disciplinary boundaries (the universe-ity of climate change and social inequality do not require your having the proper academic credentials).

This renewing of responsibility as a collaborative enterprise operates as a form of meta-research: not that of filling a knowledge gap but entailing a larger questioning of how we acquire it and determine its value (out of which the abyss of unknowing gapes before us). A rigorous purposefulness that invites play, replay, and reframing also involves the prompting of the question "what is the meaning of what I am doing," which, among other benefits,

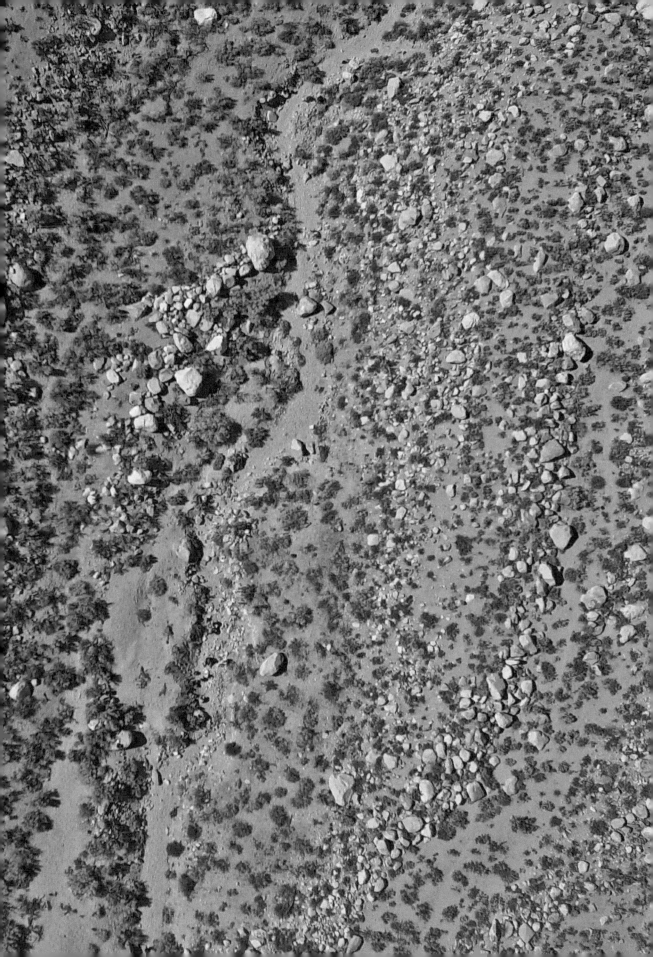

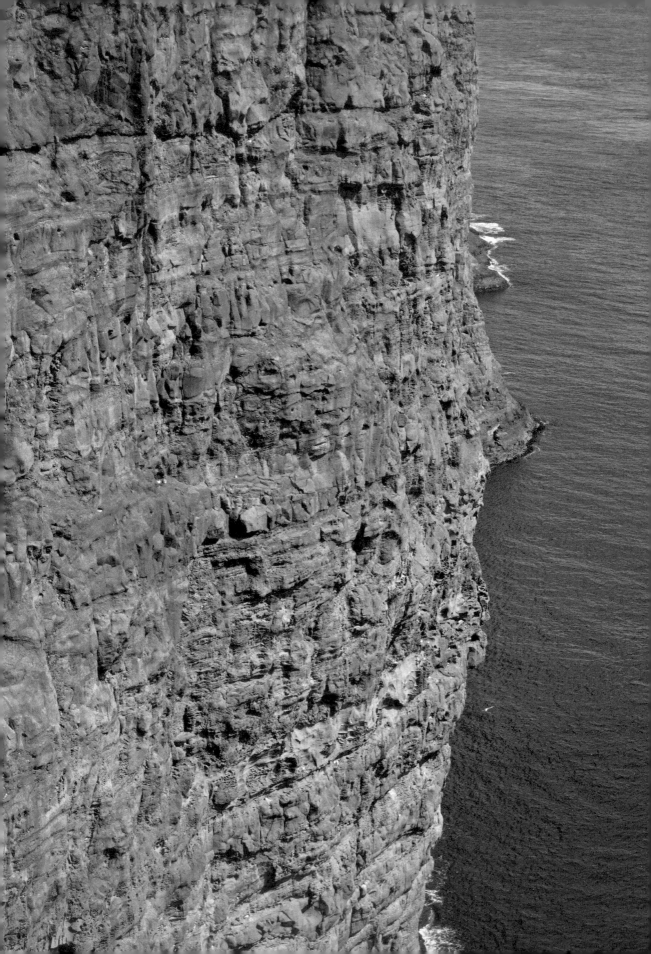

brings to bear more interesting research questions. And this invites appreciation of the privilege of those of us who occupy the academy, a reminder that our institutional structures are not made of inert and immobile matter. While it may not represent a tectonic shift, the work described in the pages that follow mobilizes us to reflect more deeply and consciously about our collective ambition of making sense of our fractured, distressed, and terrifyingly beautiful world.

IMAGE ON NEXT PAGE

Artist Marek Ranis

Title *Liminal Landscape*

Year 2020 Medium Mixed media on linen

Dimensions 67" × 74"

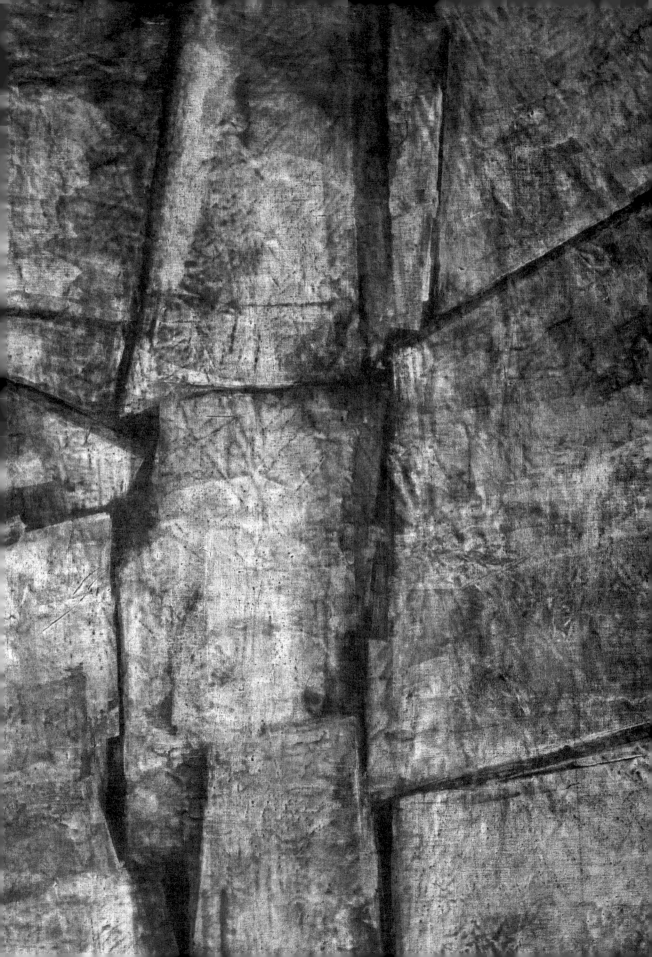

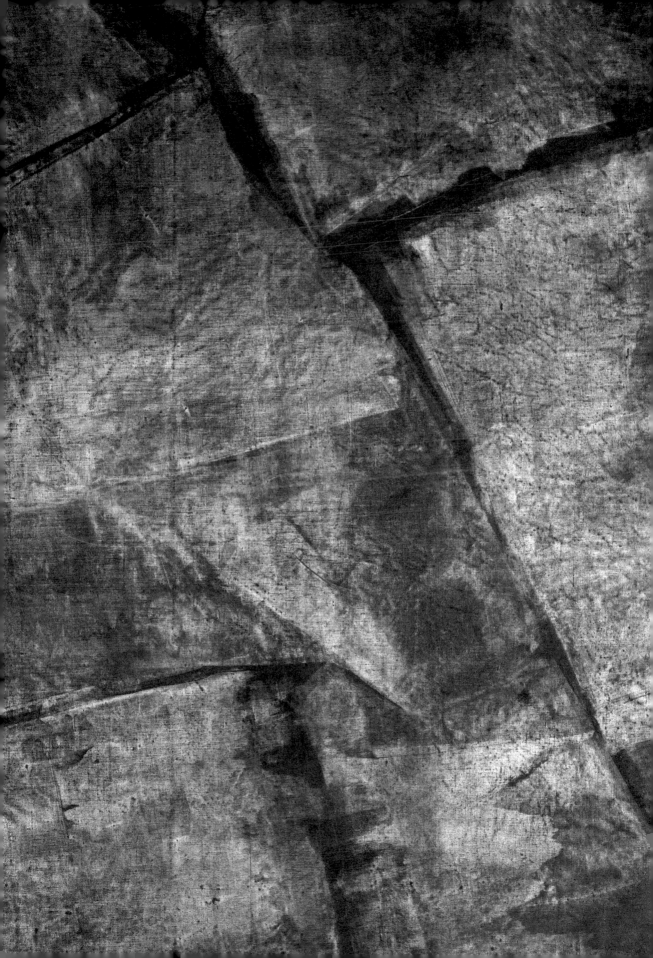

Introduction

By José L. S. Gámez, Associate Dean for Research and Graduate Programs, College of Arts + Architecture, UNC Charlotte

I am not a scientist.

Sadly, I am not an artist either.

I am, however, a doctor – just not the kind of doctor that can help with much beyond architectural, urban, or cultural theories. Architecture, often described as a blend of art and science, struggles to advance while maintaining balance; the science advances but the aethetics run their own course–or vice versa. As these two aspects of my home discipline wobble forward, gaps often emerge and so do opportunities to glimpse other futures. I am interested in those gaps, in what they might offer as locations for other ways of working to be brought in. In that sense, I am a student of the spaces between art and science.

As it turns out, I am also a student of science and art and of the immense creativity that I have witnessed that underlies all aspects of the work contained in the following pages. The aim of what follows is to capture the spirit of a unique multiyear, multidisciplinary grant; the artistry and rigorous inquiry focused on basic hypothesis-driven science and underexplored concepts across a range of disciplines has resulted in outcomes that may seem conventional (conference papers, scholarly articles, undecipherable equations) and others that are a bit less so (dance performances, film, digitally printed paintings). What began as a National Science Foundation (NSF)-sponsored collaboration between an artist, a geologist, and a scientific team (that includes PhD students and experts from the United States, Israel, Japan, and the United Kingdom) resulted in a novel collaboration representative of the type of multidisciplinary synergies increasingly sought by federal and scientific funding programs.

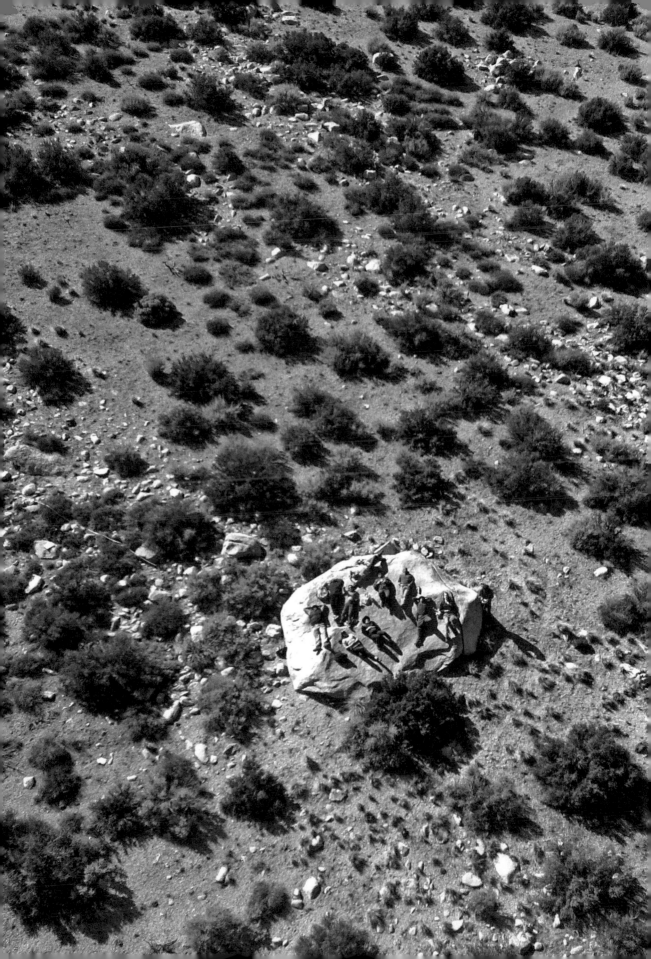

But I should point out, as Ken Lambla (founding dean of the College of Arts + Architecture at UNC Charlotte) states in the final essay of this book, the innovation sought through this collaboration was not accidental. Built on an NSF proposal titled "Quantifying Climate-Dependent Subcritical Cracking and Mechanical Weathering over Geologic Time," the original NSF proposal included, at its inception, a collaboration with the UNC Charlotte College of Arts + Architecture to incorporate an "artist-in-residence" for this multiyear geological study. The aim of this artist residency was to develop material that communicated research results focused on basic subcritical cracking concepts – not well-known in the geomorphology community – as well as creative case studies and artistic contributions.

All of this because rocks crack. And, they crack in important ways.

For Marek Ranis, a multimedia environmental artist who teaches in the Department of Art and Art History at UNC Charlotte, the rocks that provide gaps for geological study also provide spaces through which to view our ever-changing universe. His essay evokes the deep contemplation that only an artist can conjure; his reflections on landscapes and memory remind us that there was a time when divisions between art and science were unthinkable. Dr. Martha Cary Eppes, or Missy, is a literal rock star – a professor of earth sciences at UNC Charlotte – who explores mechanical weathering and the physical breakdown of the Earth's surface rocks. Her essay illustrates the fact that the factors that drive or limit mechanical weathering remain poorly characterized within the fields of geology and earth sciences. As a result, they remain virtually unknown among the general public. What Missy provides is a way to understand the role that multidisciplinary work plays within broader discussions of the Earth, weathering, and geological models.

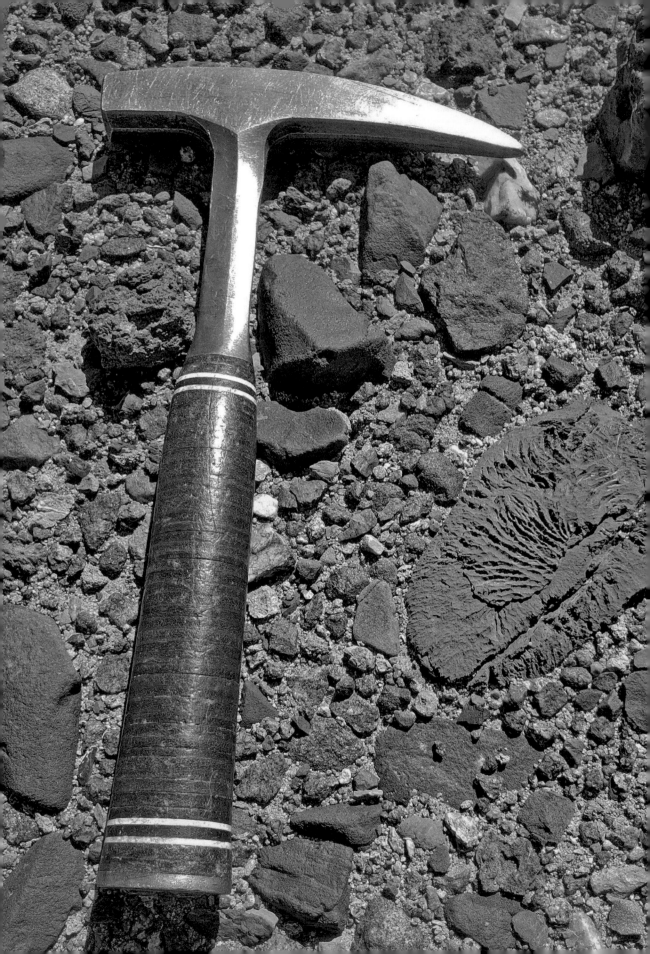

Missy and Marek's collaboration has already impacted future scientists like Monica Rasmussen, a doctoral candidate at UNC Charlotte working with this NSF team. Monica shares some reflections of this multiyear project, which help illustrate questions that may shape future art/science collaborations and researchers. And, their work has informed the work of other artists, like Melissa Riker, a New York-based dancer, choreographer, and artistic director whose Kinesis Project has engaged scientific works from which artistic productions have emerged. Melissa describes the *geological proportions* of environmental and emotional stresses we often find ourselves confronting.

The unconventional collection of actors featured throughout this book has impacted its format: what you see is a field guide of sorts – a notebook richly illustrated with research images produced in concert and separately. Clearly, this is not a textbook; text is interrupted by galleries featuring images of the landscapes being studied, of artistic works, and of researchers (including the artist and students) engaged in a range of activities. As such, the publication blurs boundaries between the presentation of art and science, scholars and students, and researchers and artists. The goal is to share a narrative about the experience, its meaning and potential impacts and, by extension, provide a model for other teams to collaborate in similar ways in the future.

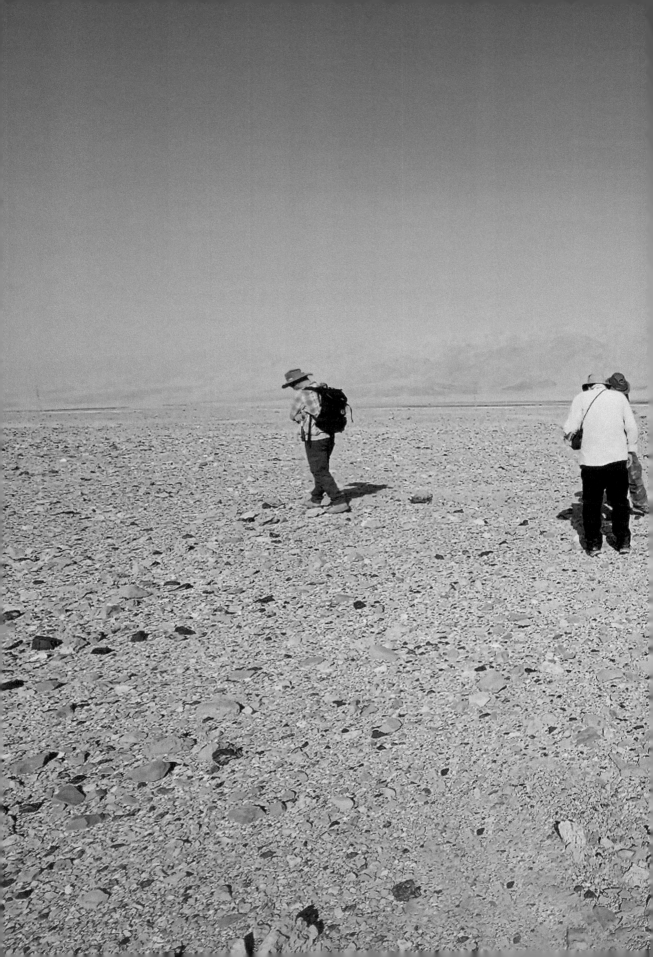

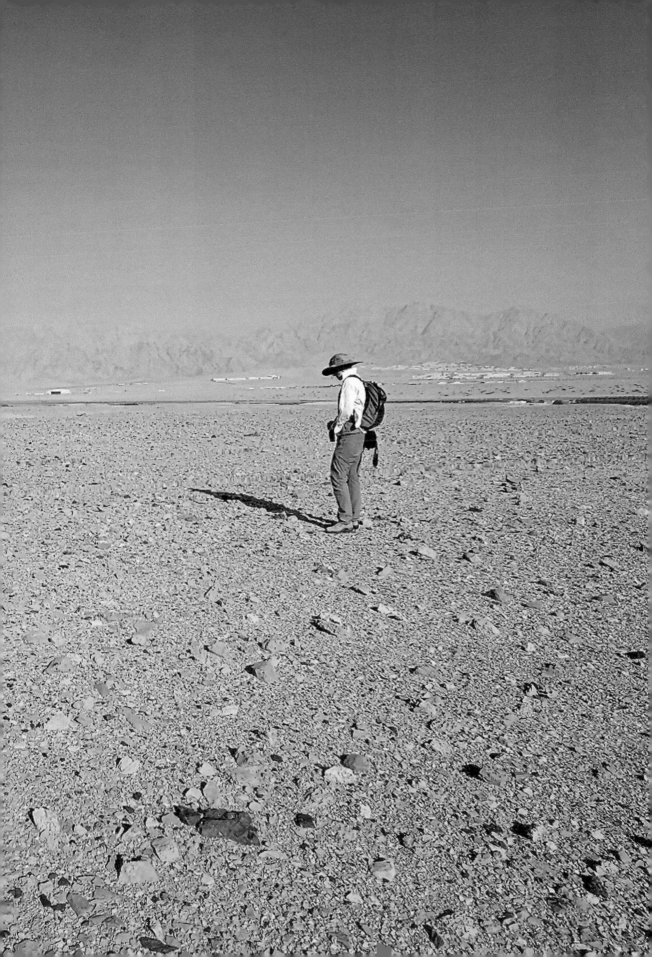

Cracking Up

*By **Martha Cary (Missy) Eppes, Professor, Department of Geography and Earth Sciences, UNC Charlotte***

Can I convince you to love cracks in rock as much as I do?

There is no rock on Earth that does not have fractures. These cracks are ever-evolving defects caused by the greatest, and smallest, of forces. They may be broad and gaping, defining the rock more than its other characteristics, or they may be microscopic, invisible to the naked eye but ubiquitous, stealthily impacting the rocks' evolution and character. They impact everything from a rock's tendency to completely break down and its ability to withstand great stresses, to its capacity to hold a reservoir of resources. I challenge you to name a single event in Earth's history that was not connected in some way to fractures.

Fractures impact every conceivable process shaping the Earth's surface. They control how rivers cut into rock, how glaciers erode, how volcanoes erupt, and how landslides occur. They regulate the size and number of pebbles and boulders sitting on Earth's surface and the formation of soils that enable life on our planet. The growth of fractures also allows water to infiltrate into rock and further break it down through chemical reactions. Amazingly, it is even possible that when tectonic plates collide, growing and cracking mountain bedrock, the ensuing fracture-enabled chemical reactions use up so much carbon dioxide from the atmosphere that the planet cools down. In turn, this observation begs the possibility that rock fracturing could somehow save us from the horrific trajectory of global warming on which we have placed ourselves, our planet, and all its flora and fauna.

The overlay of fractures across virtually every natural process impacting Earth's surface where humans reside, and across the realm of our own human destiny, would

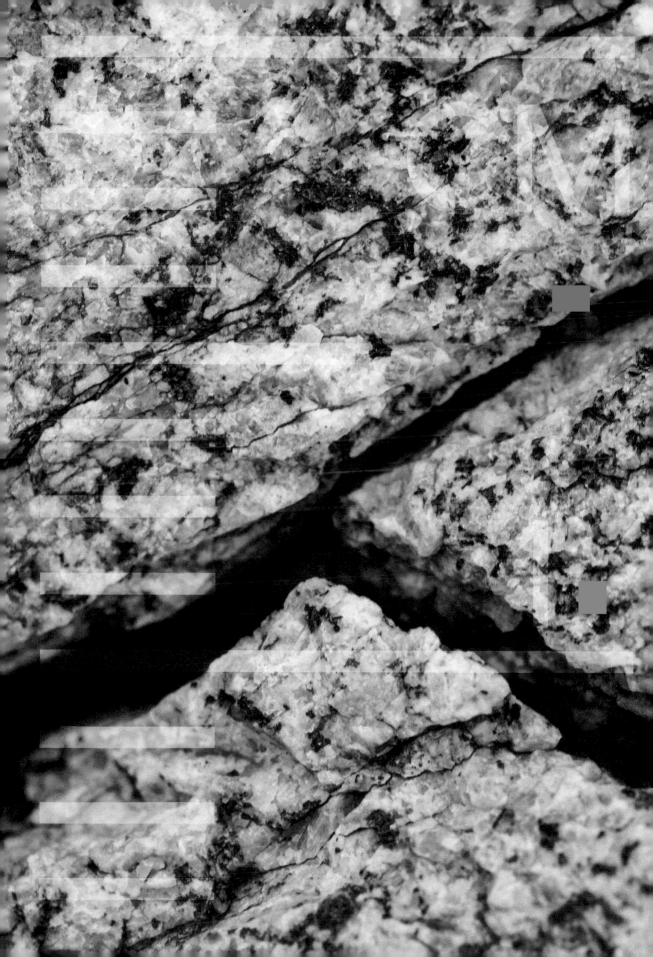

seemingly raise fractures to a high priority as a subject of research. Yet even as of the writing of this essay, twenty years deep into my own research, we still know surprisingly little about how or why rocks crack.

I came to the realization that we did not fundamentally know squat about rock cracking early in my career. As a graduate student, I joined forces with Professor Les McFadden to test his brilliant hypothesis for how the sun might crack rocks when they are just sitting peacefully and quietly on the desert floor. Since the 1930s – because a well-known physicist of the time had conducted oven experiments that failed to produce cracks – it had been mostly discounted that the presumably low forces caused by daily heating and cooling could cause rocks to break. Les, however, had the insight that Earth's surface is not like an oven, evenly baking rock from all directions. Instead, Earth's surface receives directional heating as the sun transits from east to west across the sky. Les guessed that this directional heating may be enough to cause cracks to grow, and I was hooked. As I was finishing my PhD in a completely different subject, "on the side" we tested Les's hypothesis by measuring the directions of hundreds of cracks found on those desert floor rocks. We presumed that if directional heating was causing fracture, the fractures would have "direction." Sure enough, the vast majority of those cracks we measured in the deserts of the southwestern United States point north, almost like a natural compass! We therefore showed with our data clear evidence of the culpability of the sun in cracking rock (McFadden et al., 2005).

When I moved to humid North Carolina from the desert Southwest, I was naturally curious if I would observe the same influence of the sun in a location where, unambiguously, other rock cracking actors were in the theater (lead role: freezing, her accomplice: water). So we measured many more hundreds of cracks on hundreds of

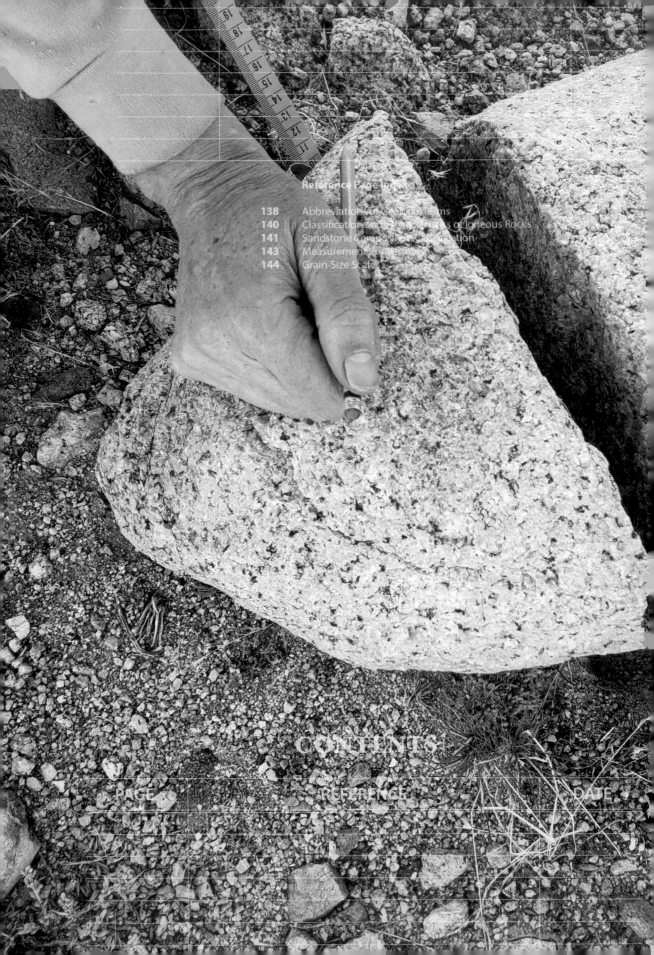

CONTENTS

PAGE	REFERENCE	DATE

rocks not only in North Carolina, but also in Pennsylvania where rocks had been sitting there for thousands of years, mere kilometers from the margins of the ice sheet covering that part of North America in the last ice age. Surely, freezing forces would dominate rock cracking in this environment, as had been hypothesized by innumerable geoscientists over the years, and no trend in crack directions would be observed. But, by virtue of the East Coast cracks' north-south orientations roughly matching those of their desert cousins, we concluded that forces associated with freezing were not particularly influential.

The preferred orientations of these newly measured cracks found on rocks sitting in a forested, hot, and wet environment also pointed to the sun as a primary influence on their formation (Aldred et al., 2016). That remarkable observation led me away from geomorphology and into the field of fracture mechanics to better understand how it was possible that such small day-to-day stresses could leave their mark on cracks that should be responding to the massive forces that water produces when it freezes (think of your exploded wine bottle in the freezer).

I was not disappointed in my journey. Fracture mechanics and its related fields in geosciences – rock mechanics and rock physics – supplied answers of which I could never have dreamed from my perspectives as a geomorphologist. It turns out that we geologists studying "mechanical weathering processes" like freezing had actually been studying "stress loading processes" (i.e., all of the ways that forces arise at the surface of the Earth that are sufficient to crack rock). We had paid little, if any, attention to the actual cracking process itself (i.e., the chemical bond-breaking that epitomizes the opening of space in a rock body made of minerals).

Of course, other scientists studying fracture mechanics had long considered bond-breaking processes, and it turns

out that these processes can be broadly categorized into two groups. The first is how most of us had thought about fracture if ever we had gotten that far: like the snapping of a pencil in anger. This "snapping" is the bond-breaking, and thus cracking, that occurs when a material experiences stresses greater than its "strength" – as measured in a laboratory. I call this type of cracking "critical" cracking.

It is worth a side note to mention that I was recently admonished in my definition of "critical cracking" by reviewers of one of my research group's papers. Appalled, I dug back into literature and conversations with my colleagues to get to the bottom of this "mistake." From that, I deduced that it was not a mistake at all, depending on your point of view, just a lack of clarity of my meaning, highlighting the fact that vocabulary shares many connotations across disciplines. Terminology, undefined in detail, can be easily misconstrued. So here I acknowledge there may be other definitions, and further define my use of the term "critical cracking" to refer to cracking that occurs rapidly and unstably, a "runaway" propagation like that of a smashed back door window after a force is applied to an area of rock making a stress (force per area) that exceeds the rock's strength. My kind Reviewer #2 reminds me to emphasize that such cracking may subsequently slow down if the force does not continue, yet still remain "critical" only because its initiation was due to a critical force.

Semantics of critical cracking aside, the second category of cracking I "discovered" in my exploration of fracture mechanics literature was "subcritical cracking." This term is widely accepted to describe the type of cracking that occurs at stresses below or even *much* below the strength of the material. It occurs relatively steadily and slowly, like a slow-growing crack in a plaster ceiling. Importantly, experiment after experiment in rock physics laboratories, coupled with investigations from the ceramics industry, had shown that the slow bond-breaking of subcritical cracking

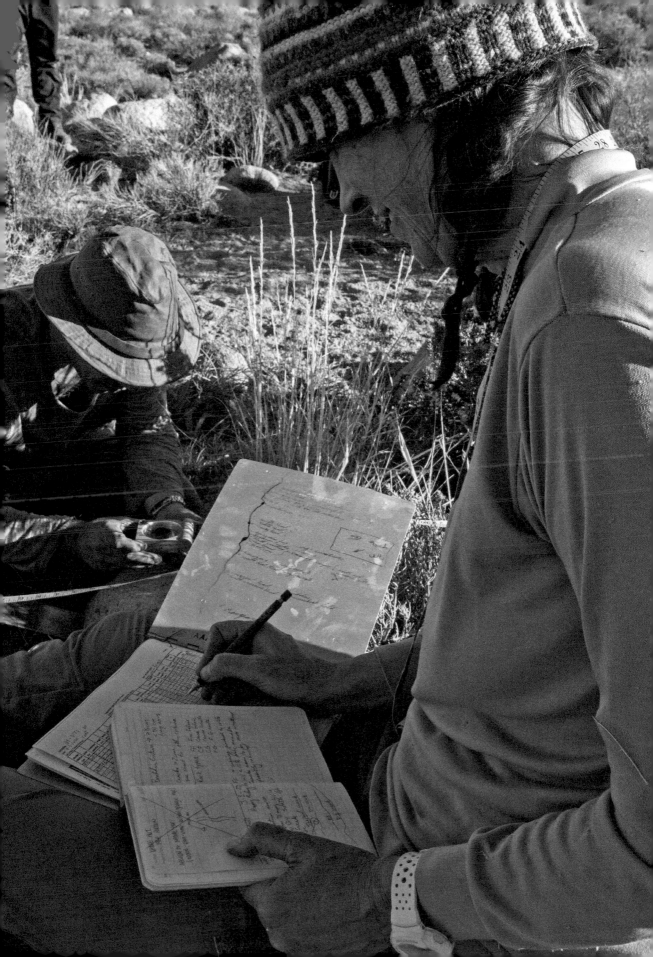

is a chemo-physical process. That is, external forces become concentrated right at the few *molecules* found precisely at the crack tip. Those forces stretch and weaken those molecular bonds such that any water that has found its way into the crack tip – as either liquid or even vapor – becomes reactive with the molecules and forms a weaker bond. Now the same old, very low stress is acting on a weaker molecular bond at the crack tip, and the crack can and does propagate. The key concept found in understanding the bond-breaking processes of subcritical cracking is this: because chemical reactions are part and parcel of rock subcritical cracking, any external factor that influences chemical reaction rates – like moisture, temperature, water chemistry (climate!!) – can also influence rock cracking. I was amazed and astonished that we geomorphologists had never thought of it before! The idea has huge implications for the role that climate, and climate change, might play in all rock fracture.

This dependence of mechanical fracture on chemical reactions – and thus on climate – represented an ineffable revelation. First, I had never even heard of it despite a decade of prior fracture-focused research. I scoured surface processes and weathering literature looking for a reference to these subcritical processes and found virtually none, only a few invocations of subcritical cracking here and there, but none whatsoever about its dependance on climate (Stock et al., 2012; Walder & Hallet, 1985; Hooke, 1991; Molnar, 2004). (I deeply regret that I missed an extensive summary of subcritical cracking in Professor Yatsu's book on weathering when I first published these ideas).

More importantly, I was stunned by the implications of understanding that all natural rock cracking must be subcritical to some large extent. If, all other things being equal, climate fundamentally controls these subcritical cracking processes, then we had been ignoring a fundamental climate-dependent process in our work.

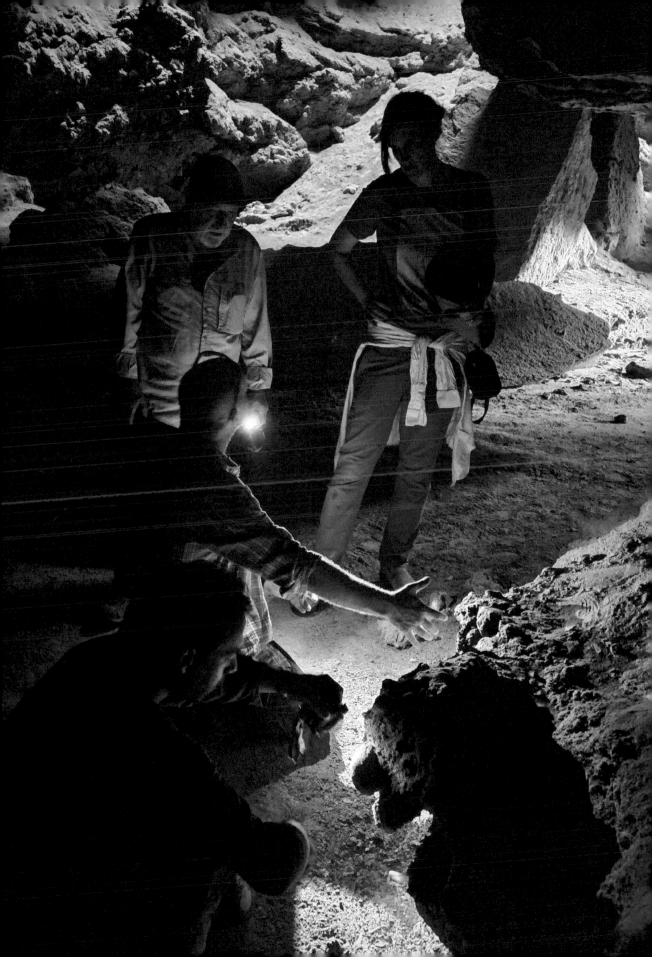

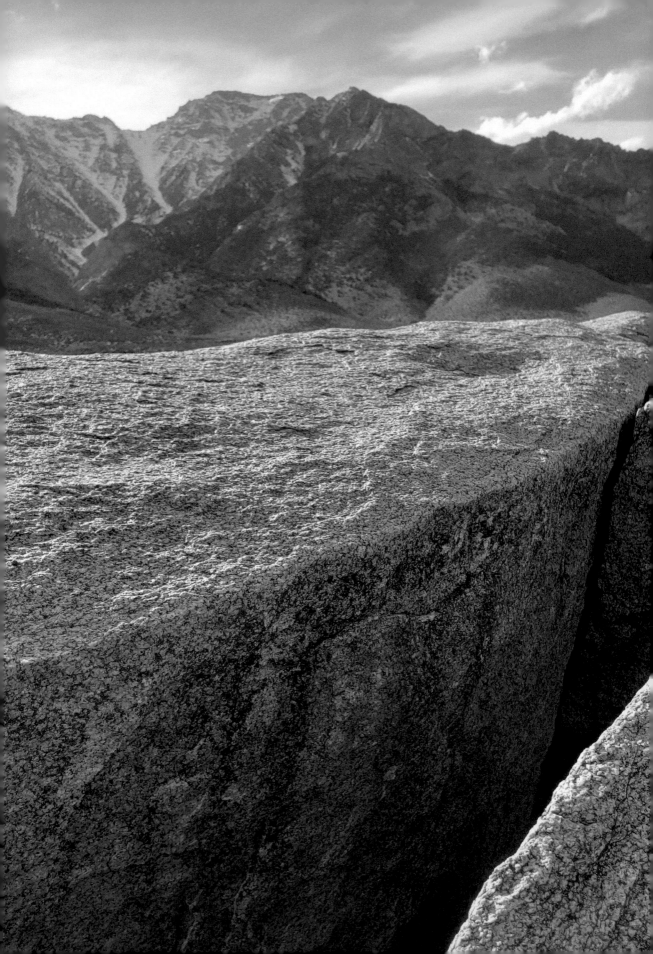

I cannot overexaggerate the plethora of papers in the field of geomorphology that are titled "The influence of climate on...." Because rock cracking is so integral to so many processes, my "discovery" meant that we had been ignoring one possible – but crucial – piece of the puzzle for why or why not different natural systems respond to different climates. Also, by virtue of the fact that laboratory experiments showed time and again that subcritical cracking proceeds faster as temperatures increase, it followed that exposed rocks – including those comprising hazardous locations, or cherished cultural stone monuments like Petra, Stonehenge, the Sphynx, and Mount Rushmore – will decay at faster rates with ongoing global warming. Incredible.

During my voyages between geomorphology and rock mechanics literature, I also began to appreciate that the lack of recognition of subcritical cracking in surface processes research had been largely attributable to the large number of different terms employed in the rock physics literature to describe the same process: fatigue, stress corrosion, time-dependent cracking, environmental-dependent cracking, static fatigue, progressive failure. All of these expressions refer to what could be described as subcritical cracking, but the lack of a universally employed, single word inevitably makes finding the associated concepts so much more difficult. Climate-dependent subcritical cracking of rock was a concept that had been hiding in plain sight, even in some of our own surface processes literature, but no one had put two and two together. In fact, when I presented these findings at professional conferences, my fellow geomorphologists suggested I prove the efficacy of climate-dependent subcritical stresses by cracking rocks in the lab. I enthusiastically responded that those experiments had already been completed! So, in effect, my "big idea" had been at the party the whole time. I just translated an invitation for her to join the dance floor and made a happy announcement to the crowd!

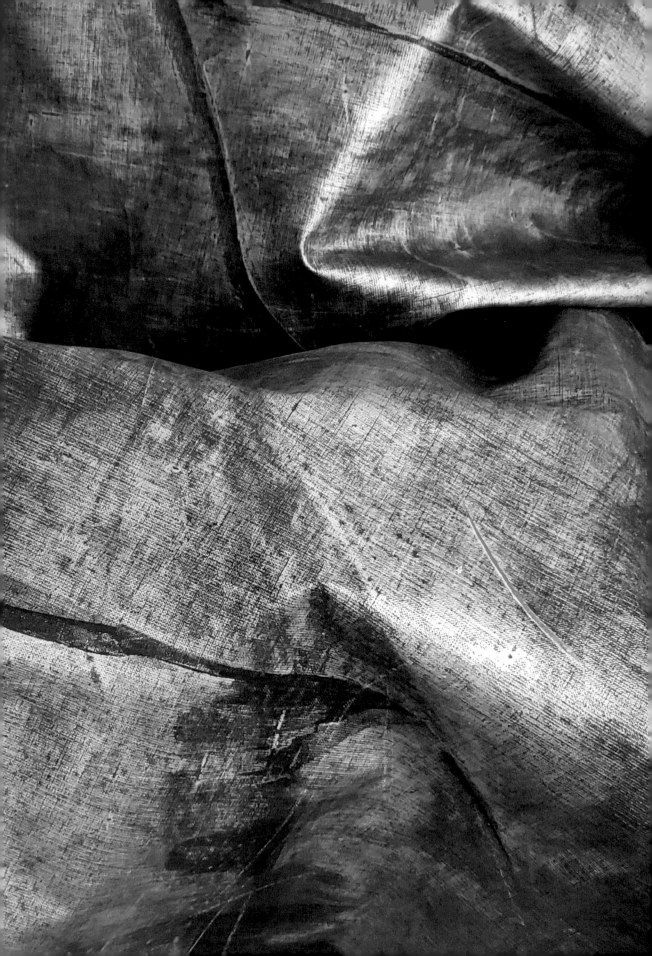

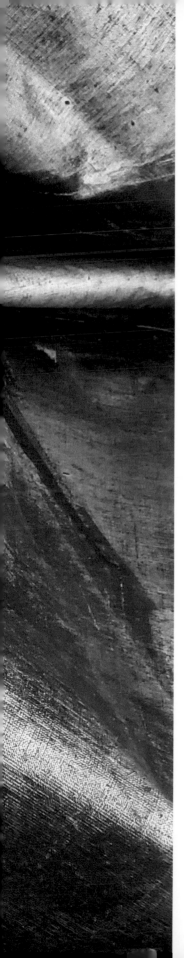

This "you ain't got the right keyword" barrier should be familiar to anyone whose Google search has utterly failed. Thus, my story serves to reemphasize the idea that terminology often stands in the way of knowledge-building. So often, we are entrenched in our own perception of language that we fail to see the intended concepts behind the words of the speaker. Yet if we cannot effectively communicate, we cannot make connections and move forward together.

I believe that nowhere are communication barriers more apparent than the American public's current lack of trust, understanding, and appreciation of the sciences overall. Resistance to listening to science imperils both science and society fundamentally and broadly. It is my opinion, for example, that the lack of diversity in the sciences – geosciences are one of the least diverse – stems directly from a hardheaded resistance to changing how we speak the language of science. The lack of confidence in science's take on vaccines or climate change stems in large part, I believe, from scientists' difficulty in explaining scientific uncertainty. To be effective scientists, we must be effective communicators, and therein lies, in my opinion, the greatest motivation for us to collaborate with artists.

My sister is an artist. I took more art classes in college than any other subject besides geology. Thus, when I realized that I could incorporate and fund an artist in my own research proposals to external funding agencies, I was certain of my path long before I stepped foot on it. The US National Science Foundation (NSF) requires that all research proposals speak to their "Broader Impacts," or how they will benefit and share the results of the work with society at large. NSF is increasingly mindful of how crucial it is that these Broader Impacts in their funded proposals be truly impactful. Artists-in-residences such as what I envisioned certainly have the potential to meet this criterion.

I planted this seed with a university administrator in the College of Arts + Architecture, Ken Lambla, years before I was ready to submit a proposal. When the time came, I reminded him of his commitment and off we went. My crack-focused research was funded by NSF with "high marks" for the artist piece. Although he was not paid salary, Ken was a co-principal investigator on the grant – an important title for university bean counters – and became a powerful and indispensable ally in this novel endeavor. He helped me understand that I would be best served by a "fine artist" who would synergistically build knowledge alongside of me, rather than merely illustrate the findings of our crack-based research. Ken wrote the advertisement for the position using the language of artists combined with my language of cracks. It was fascinating to observe his amalgamation of scientific and artistic concepts, and then to watch him serve as matchmaker to my cause.

It turns out, we found many artists interested in cracks and cracking! Ken arranged for peer-reviewed evaluations of the proposals from artists and art administrators across a range of institutions, no differently from engaging reviewers for any scientific proposal, and made the selection based on those reviews. That is how my ongoing collaboration with Marek Ranis, sculptor and multimedia artist, began. Working with Marek – and later dancer and choreographer Melissa Riker of Kinesis Project dance theatre – has broadened my perceptions of my own research unexpectedly and continuously. The "broader impact" of these collaborations has exceeded any expectation that I may have had when writing the original NSF proposal. Melissa and Marek have identified more connections between cracking and people than I could have imagined, bringing my attention to the strength of using science as a metaphor for life. For example, Marek explained that artists'

Artist Marek Ranis
Title *Subcritical* series
Year 2022-2023 Medium Digital collage, transfer print on aluminum
Dimensions 48" × 64"

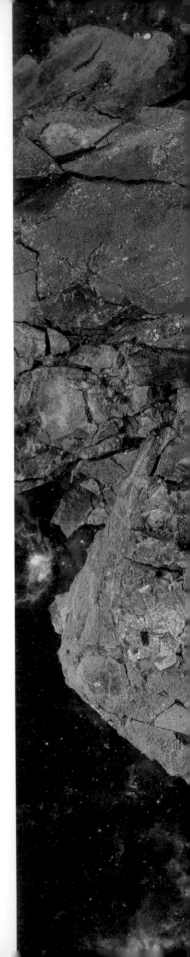

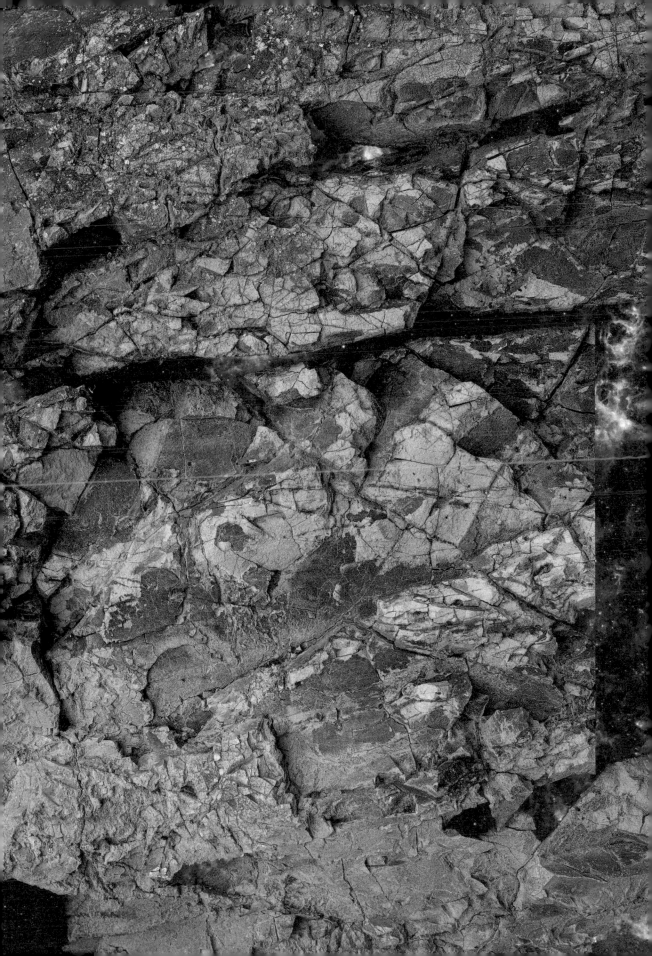

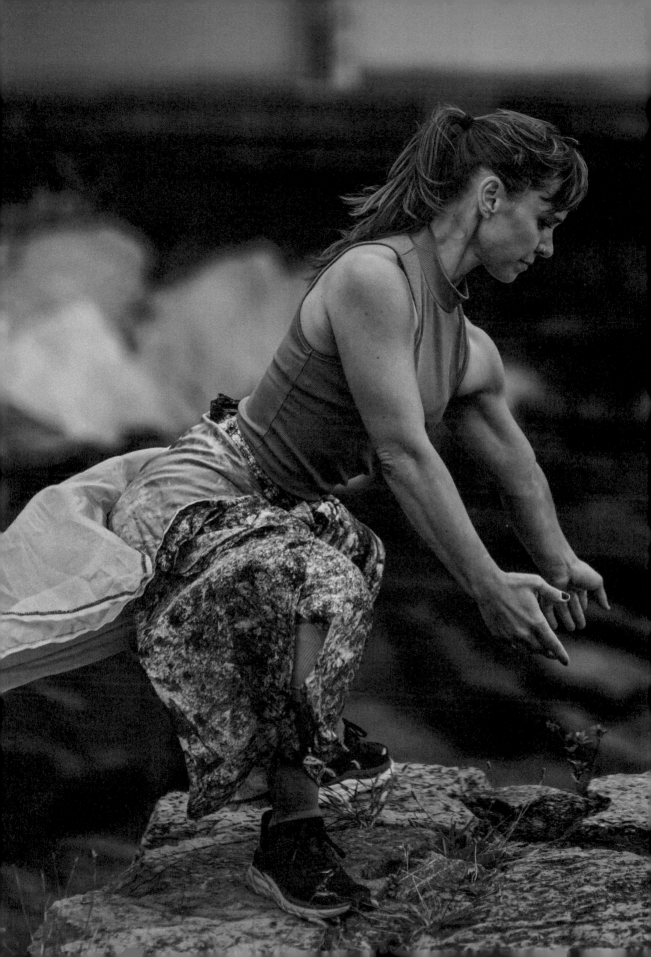

broad interest in cracking of late (there was even a special exhibit of cracking sculptures in the garden at the Louvre) has arisen because everything in our world is fracturing at the moment; social media, COVID, rising fascism places us in a liminal space transitioning out of what is predictable.

These metaphors, knowledge built about my research by the artists, provide an emotional and intellectual connection to the research beyond its practical application to societal problems – rock fall hazards, for example, in the case of cracking. Somehow stating "Subcritical is God" (Marek Ranis, during field work 2020), opens a much wider door of accessibility to the science itself than any amount of scientific literature citation ever could. In that case, recognizing climate-dependent subcritical cracking as a ubiquitous process empowers it over how mountains fall, how soils form, how life itself evolves.

These are ideas people can relate to. It was Marek Ranis who pointed out to me one day in the field: "Missy, the world thinks of climate change as melting glaciers and rising seas. You are saying it will affect us in ways we have never thought of, down to the smallest cracks in our bedrock. That is terrifying." If my research helps people understand the profound harm our planet has in store if we don't make a change, then that is perhaps its most important contribution. It was my collaboration with Marek that caused me to start emphasizing this idea.

Although it should not have been, it has been surprising to me the extent to which artists benefit from tapping into the science. Melissa cold-called me one day because she had found my cracking research online. She had been thinking of fracture in the context, also, of COVID-19 and how it fractured her dancers' figurative lives – as they had no performances – and their literal lives as their bones were breaking due to lack of use. Melissa also had already

Subject Prompt: "Journey & Pulled Apart," Madeline Hoak, New York
Photographer Effy Grey

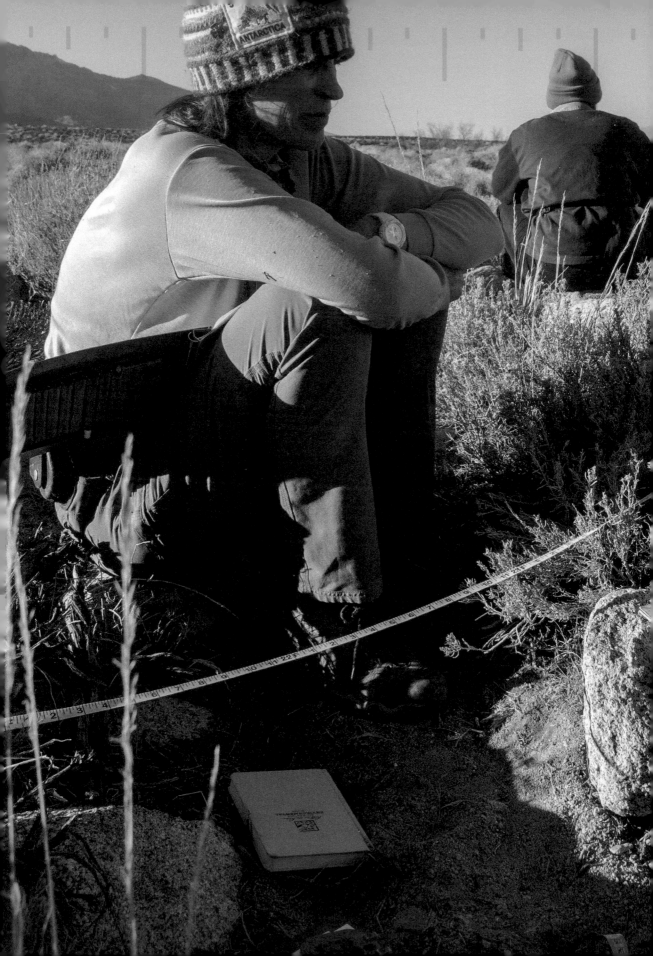

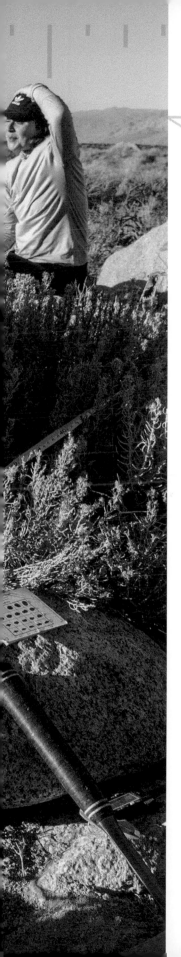

"discovered" subcritical cracking in its metaphorical sense and named it "crackling" – a word she uses in the title of the piece she is developing based on my research. For every physical process I described in our initial phone conversation, Melissa had an analogy at hand that she had already considered in the context of a work of dance she was creating. Amazing. Melissa became the artist-in-residence for a different NSF grant of mine, and we continue to collaborate to this day.

Has this book and its art and artists led you to share my fascination and obsession with rock cracking? Perhaps not, but maybe you will think more of it moving forward. More than that, really, I hope that you will be inspired to incorporate science into your art or art into your science.

I leave you with a thought that Melissa's work has proposed. We may fluidly exchange the words "person" and "rock" in thinking of cracks. I invite you to do so.

There is no rock on Earth that does not have cracks – ever-evolving defects caused by the greatest, and least, of forces. These fractures alter the very nature of the rock itself, influencing her tendency to break or heal, her ability to withstand great stresses, and her capacity to retain precious resources. Try to name a single event in Earth's history not connected in some way to cracks. Please email me if you think of one.

References

Aldred, J. *et al.* The influence of solar-induced thermal stresses on the mechanical weathering of rocks in humid mid-latitudes. *Earth Surface Processes and Landforms* 41, 603-614 (2016).

Hooke, R. L. Positive feedbacks associated with erosion of glacial cirques and overdeepenings. *Geological Society of America Bulletin* 103, 1104-1108 (1991).

McFadden, L., Eppes, M., Gillespie, A. & Hallet, B. Physical weathering in arid landscapes due to diurnal variation in the direction of solar heating. *Geological Society of America Bulletin* 117, 161-173 (2005).

Molnar, P. Interactions among topographically induced elastic stress, static fatigue, and valley incision. *Journal of Geophysical Research: Earth Surface (2003–2012)* 109 (2004).

Stock, G. M., Martel, S. J., Collins, B. D. & Harp, E. L. Progressive failure of sheeted rock slopes: the 2009–2010 Rhombus Wall rock falls in Yosemite Valley, California, USA. *Earth Surface Processes and Landforms* 37, 546-561 (2012).

Walder, J. & Hallet, B. A theoretical model of the fracture of rock during freezing. *Geological Society of America Bulletin* 96, 336-346 (1985).

Yatsu, E. *The nature of weathering: an introduction.* (Sozosha Tokyo, 1988).

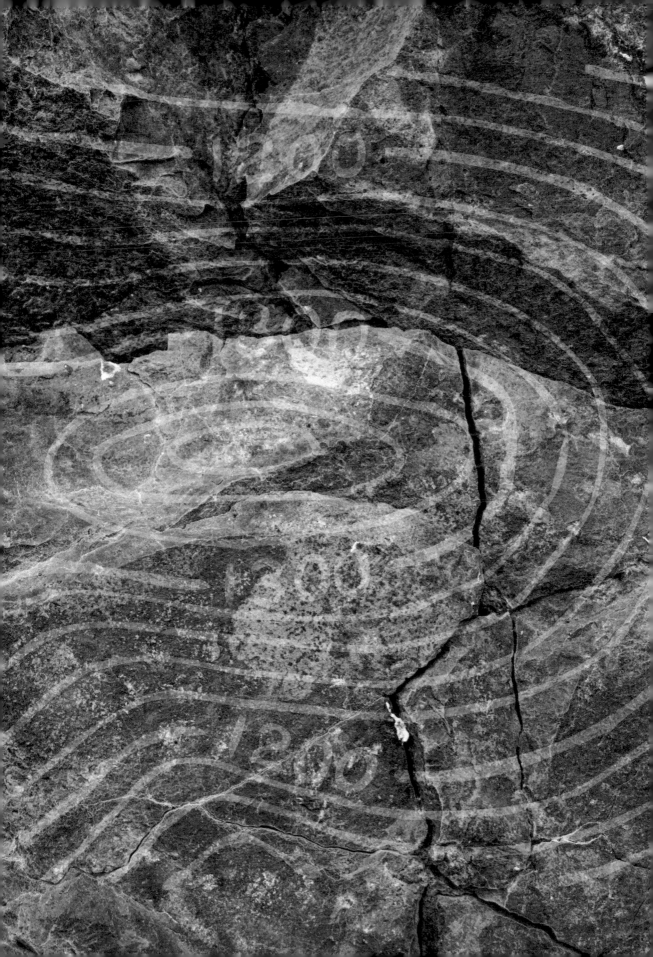

CONTENTS

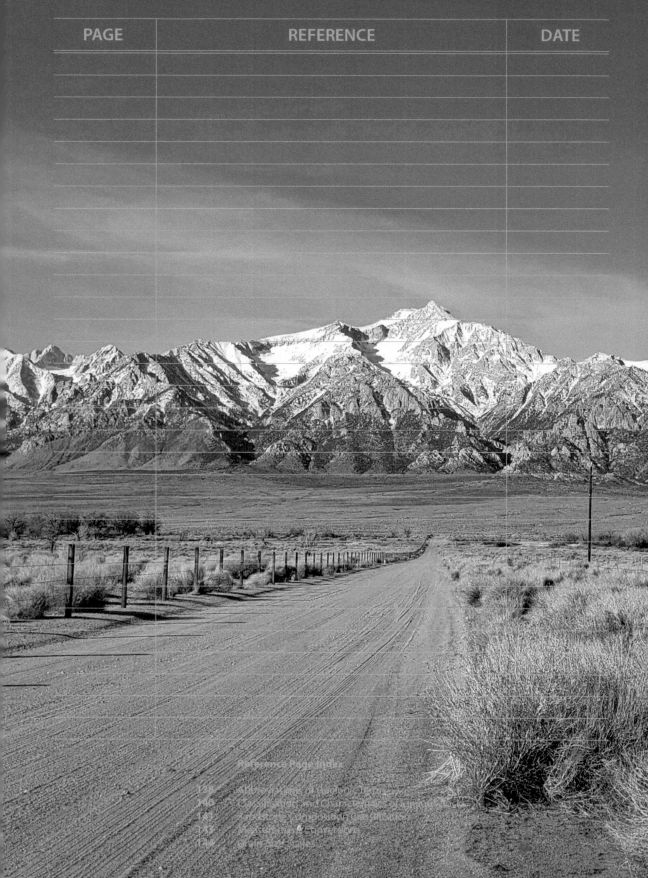

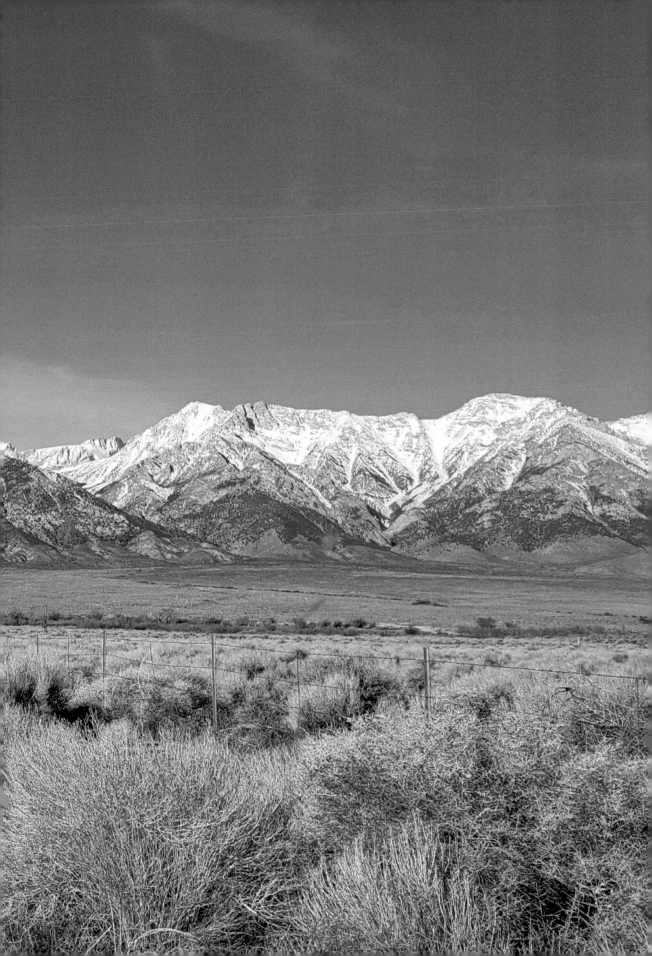

Liminal Landscape

by *Marek Ranis, Professor, Department of Art and Art History, UNC Charlotte*

Giant Mountains (Karkonosze) divide Bohemia and Lower Silesia right in the middle of Europe. They are old mountains, gently sloping to the flat valleys, not very imposing, friendly. They have not changed that much during the last few hundred thousand years. Certainly, they have not changed since Goethe was there doing his geological exploration in the eighteenth century, and they appear the same as they were during my aimless childish roaming in the last century. Over the ages, the forest on the slopes was cut and replanted, borders shifted, people moved, local languages changed; yet the massive mountain range has remained seemingly untouched by time, unmoved by human turmoil.

The memory of Giant Mountains allows me to construct my own romantic images of the landscape that I come from. The nature of those memories is similar to Caspar David Friedrich's paintings of the place, best described in German, *Riesengebirge*: not depicting a particular view but conjuring a composite image, one that is not photographic but still realistic – even if somewhat generic. Friedrich, in his paintings of Giant Mountains, was searching for a world's soul, *Weltseele*. He was rendering the secret forces animating the universe, *anima mundi* hiding in each element of nature. I see the mountains of the Karkonosze as monumental and unchangeable landmarks of my identity that I can always travel back to, places of childhood memories to be cherished.

TOP	Artist	Caspar David Friedrich		
	Title	*Riesengebirge*		
	Year	1810	Medium	Oil on canvas

BOTTOM	Artist	Friedrich Georg Weitsch		
	Title	*Alexander Von Humboldt and Aimée Bonpland at Mount Chimborazo, Ecuador*		
	Year	1806	Medium	Oil on canvas

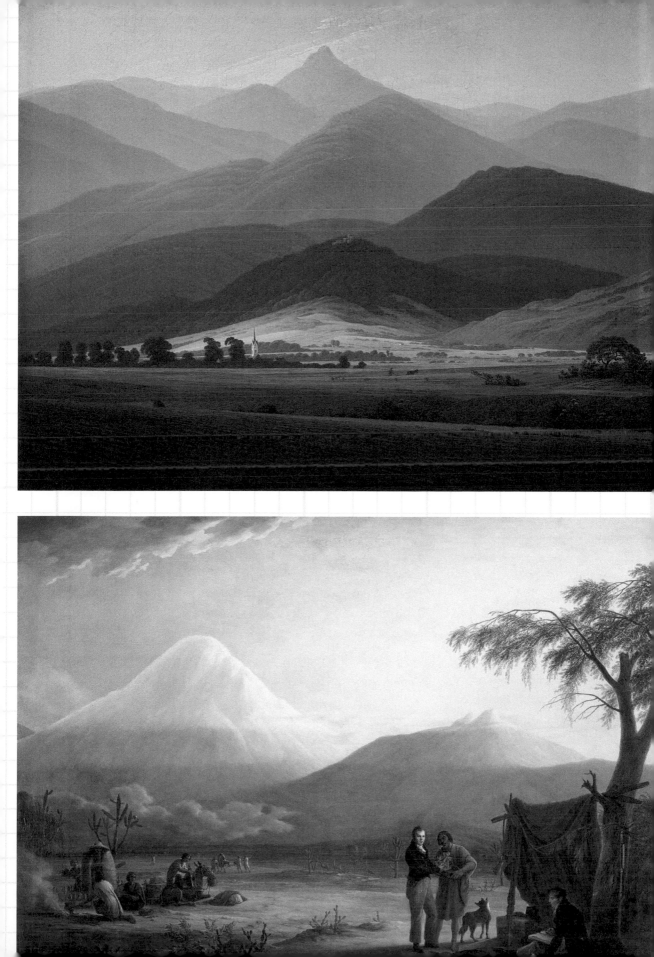

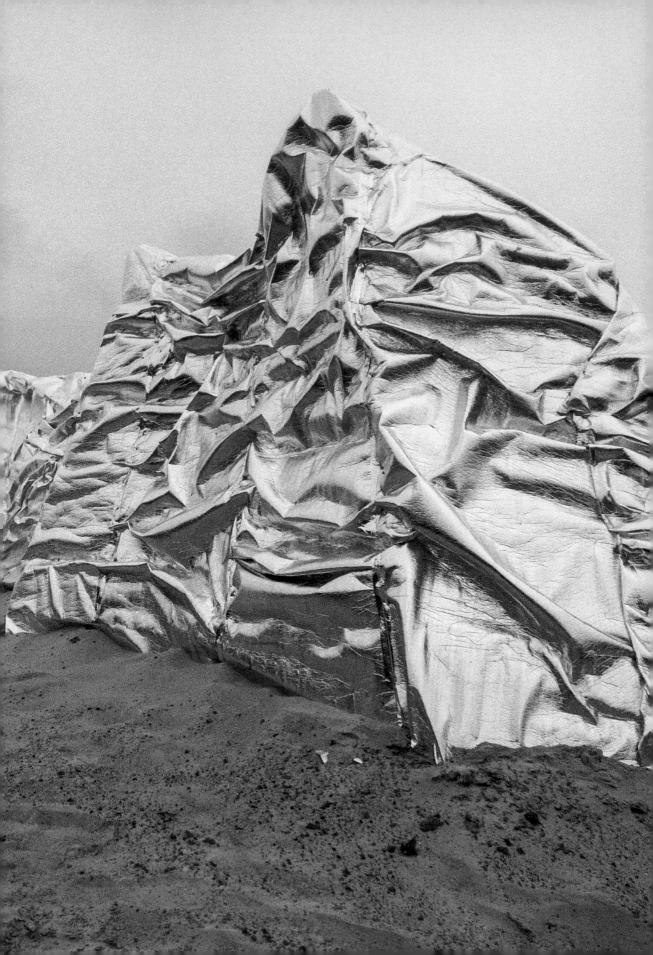

Perhaps the natural, not man-made environment is meant to give us such assurances, eternal orientation, a context, and mountains are best at it. We imagine them as primordial topographical maps of our memories. After all, we may be intuitively but falsely trusting that those are enormous rocks that we cannot move or erase.

Thus, mountains could serve as landmarks of identity. Our perception of our short human life or human presence on the planet could be measured against their immortality. Could it be that the connection to the past and the imagined future is built on the foundation of their permanence?

They were here before us and they will remain after we are gone. In the most surreal way, they provide *almost* the same vistas to all human generations, creating this dazzling connection of exactly the same experience. In literature and old prints or paintings, they always look the same. Initially, we recognize them with some surprise but it lasts only a moment. We depend on them like we depend on the stars when navigating in space and in our memories and dreams. Mountains feed our imagining of the past. When we look at the painting of Alexander Von Humboldt standing in front of Mount Chimborazo as we know it, we have a sense of the continuity of our world.

The Sierra Nevada is nothing like Giant Mountains, a much younger, dramatic, and spectacular alpine range with white caps. This massive formation is sublime, thrilling in its beauty and its terror. This natural phenomenon arrests the traveler and requires undivided attention, like an ingenious stage design. The theatrical layers, curtains of scenery superimposing one another, the sun, the moon, and the weather animating never-ending spectacles. At these altitudes, the drama can unfold at any moment. In March 2020, I traveled with Professor Missy Eppes

Artist Marek Ranis
Title *Kielzog*
Year 2008 Medium Wood on aluminum
Dimensions 40' × 7' × 8'

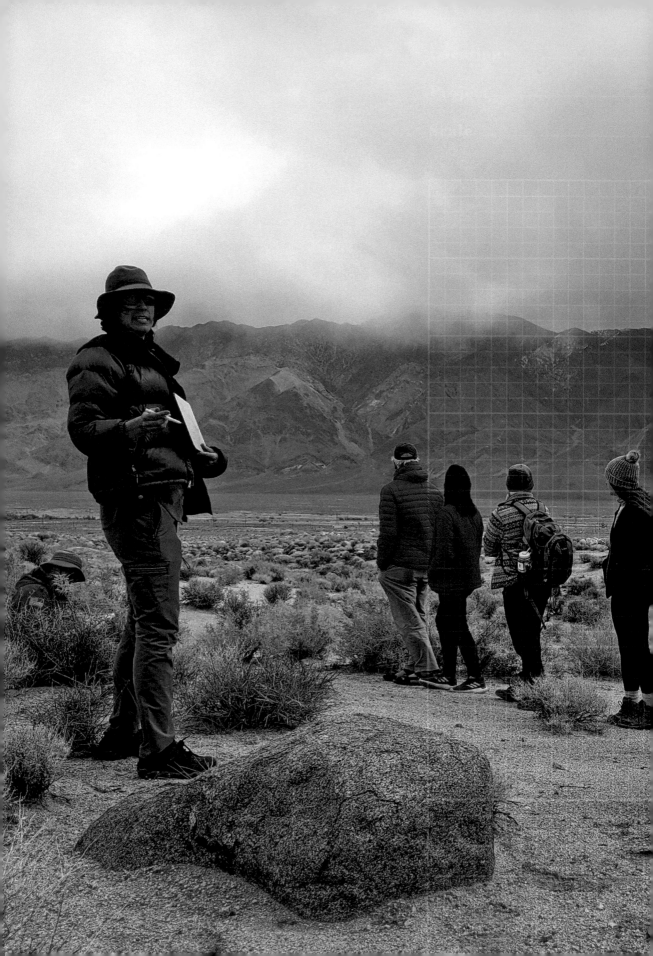

and a group of her graduate students to Owens Valley in California. I joined Missy as an artist-in-residence during her National Science Foundation-supported research "Quantifying Climate-Dependent Subcritical Cracking and Mechanical Weathering over Geologic Time." This was our first field research conducted together, the beginning of a creative collaboration and of a friendship.

Traveling along the Sierra Nevada and working in its majestic shadow with a group of geologists changed my impressions of this mountain range. Suddenly, these grand granite rocks appeared less opaque. It was due to Missy's ability to decode the landscape as a vast transparency, with all visible layers of geological processes and past events. In this context, the Sierra with its long narrative of transformation becomes unstable, more vulnerable, somehow closer to human experience. The mountains are not eternal, we know their beginnings and we can imagine their end. Observed in the context of deep time, the peaks are suddenly just smaller descendants of much more powerful formations. It is an enlightened, scientific examination of a mind equipped with knowledge and tools, which complements an initial romantic perspective.

The Sierra Nevada's perceived constancy suddenly becomes a perpetual liminality. For a geologist, there is nothing permanent or fixed. Everything is in process, in a state of flux. When the human timescale disappears, the geological time negates sublime immortality of the 14,000-foot peaks.

At the same time, we recognize that the Anthropocene and climate change are affecting the environment in ways that are visible and can be measured by the human clock.

Since 2002, my creative work and research have been centered on climate change. Maurice Blanchot, in his book *Writing of Disaster*, defines "disaster as something that is an event which cannot be transformed into an object of

knowledge; it disrupts the foundations from which we capture or perceive the reality." What initially propelled me to focus on the phenomenon of climate change, besides the acuteness and extent of related events, is the fact that we seemed not to fully comprehend this impending catastrophe. Perhaps this is due to its enormous scale, often geographical remoteness, a lack of longer-term historical perspective, or wrongly understood economic interests. Historically, huge events have often been fully fathomed only retrospectively. Many representations in my projects could be considered "visualizations of an Anthropocene experience." The subject of degradation, an ongoing ecological catastrophe, inspired and continues to inspire me to create a record of artistic interpretation of the environment under stress, the disappearing world. Some might call it the art of imperial nostalgia.

It felt very natural to work with Missy. The geologist's perception of deep time exposes the vanity of our quotidian sense of time, "human time." Nothing is stable or permanent anymore, including our species, which is, at best, an accidental ephemeral glitch of nature. The environment is suspended in a liminal space, like an alluvial fan in a frozen animation, transitioning from one state to another and another.

The subject of Missy's research – tiny spaces of cracks observed and measured through slow, meticulous, tedious processes – produces a sense of an unstable, volatile environment. Those hardly visible tiny cracks could be a potent symbol of our generation's romantic *Weltschmerz* (World Grief).

The early studies in geology cannot be separated from Romanticism. Rocks were collected, studied, painted, and written about simultaneously; yet, after Goethe, the divergence of arts and science led to modern specialization, and arts and geology have been separated ever since. Was

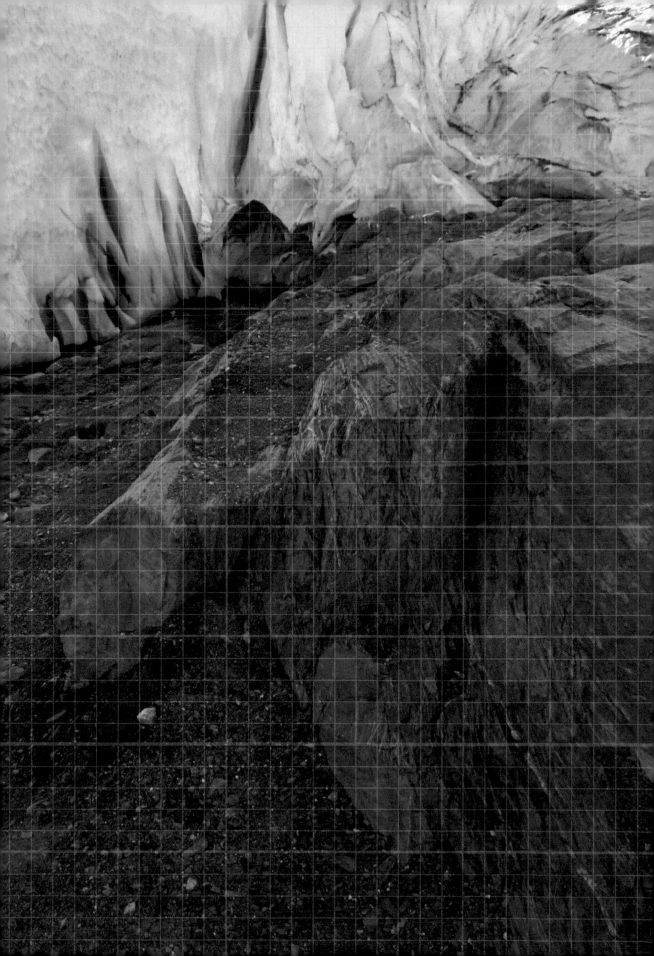

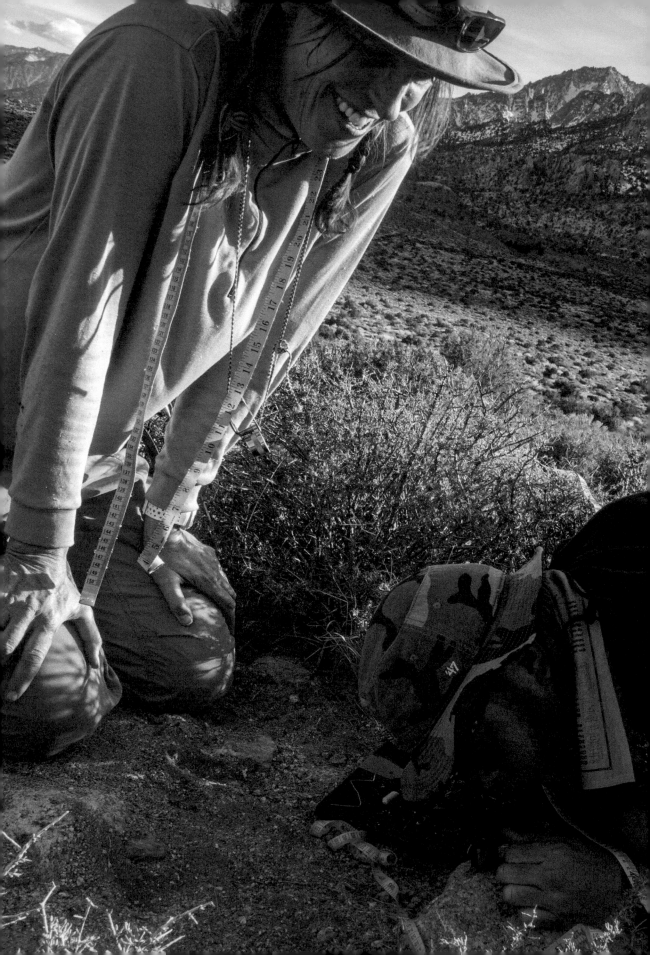

the loss of an aesthetic judgment diminishing our ability to gain access to one more dimension of understanding the reality? What became of the cyanometer, a simple device invented in the late eighteenth century to measure the blueness of the sky, the most mysterious and elusive color?

Thousands of crack measurements collected in the field by Missy and her team are slowly building patterns, like a pointillistic painting, resulting in a clear image only when seen from the distance. A geologist decodes the landscape in a similar manner to Friedrich translating the patterns of colors, textures, and forms into the meaningful picture of understanding what secret forces are animating our universe, the *anima mundi*.

This slow, methodological process of observation and search for the truth in representation is close to the experience of an artist, even though artists aim for the picture tinted by subjectivity and freedom of interpretation, often controlled by emotions.

In my imagination, the climate-related subcritical cracking of the rock is coincidental with cracking ice of calving glaciers, the poster child of the Anthropocene. It also inspired me to think about the beginning of life on Earth, the erosion of the *Supermountains* and the seeding of the world with critical nutrients. Is the erosion of the *Supermountains* hundreds of millions of years ago and the nucleation of the world through sedimentary fans a beginning of life's evolution on Earth? Is rock cracking the beginning of life? From the tiny, microscopic cracks of individual rocks to mountain ranges slowly eroding, the discrepancy of the scale and the divergence of processes exude a sense of ephemerality of the world.

Owens Valley, California, 2020: Paintings

The research project with Missy was impacted by the global pandemic in its infancy, right after our trip to Owens Valley. Unable to travel, I settled in the studio for a few months. The first series of works, paintings titled *Liminal Landscape*, are portraits of tiny cracks in granite rocks, or maybe they are aerial views of the tectonic plates. Looking like gray ice floats, they are polar landscapes in negative. Large grainy paintings with distressed surfaces, with hundreds of lines, are the excavated monochromatic maps, from undetermined location or geological era. They emulate magnified views, are an observation of the micro to understand the macro. This body of paintings was produced in the pandemic isolation; they are dark and sober, minimalistic, geometric abstractions.

To create the work, I stretched large linen canvases on walls, applied layers of paint, one on top of the other, only to wash some away, sand, and reveal – and paint over again. Paintings are done but they are unfinished, their weathering processes just interrupted, an analogy of the rocks picked up in the field and moved to the lab in a maneuver that arrests the exposure and disintegration.

Metaphorically, the *Liminal Landscape* series imitates the geologist's experience in the field, the perseverance of laying down in the dirt, face close to the magnifying glass, gaze focused on a specimen. When the scientists were observing and documenting their subjects, clutched to the rocky surfaces, I was observing and documenting them from the drone, a group of almost completely motionless bodies spread over a predefined perimeter, a macro view of their micro investigations.

Artist Marek Ranis
Title *The Dam*
Year 2022 Medium High-definition video, 5 min. 21 sec.
Dimensions Video still

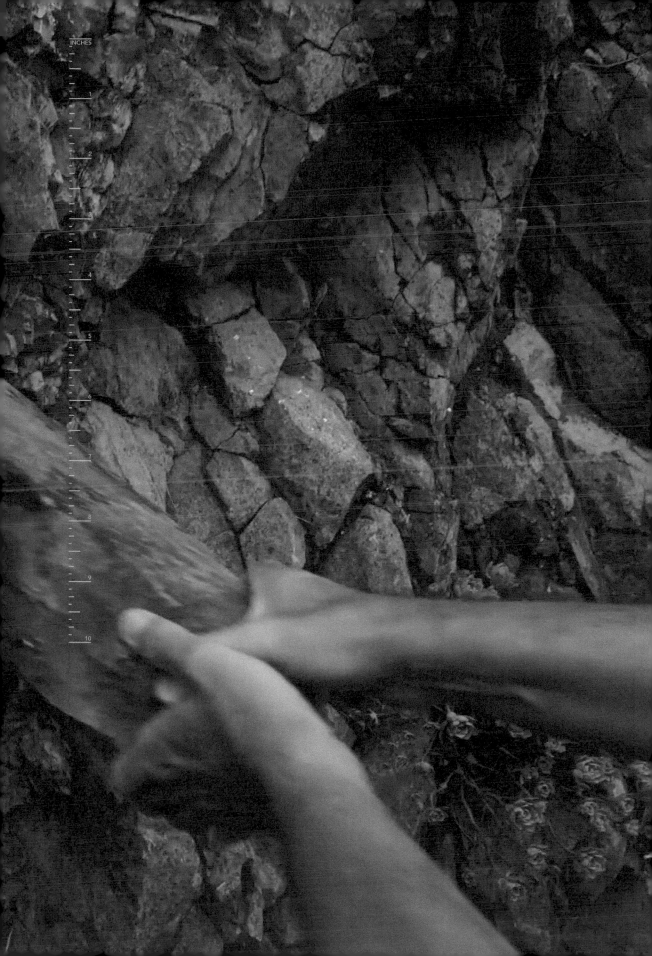

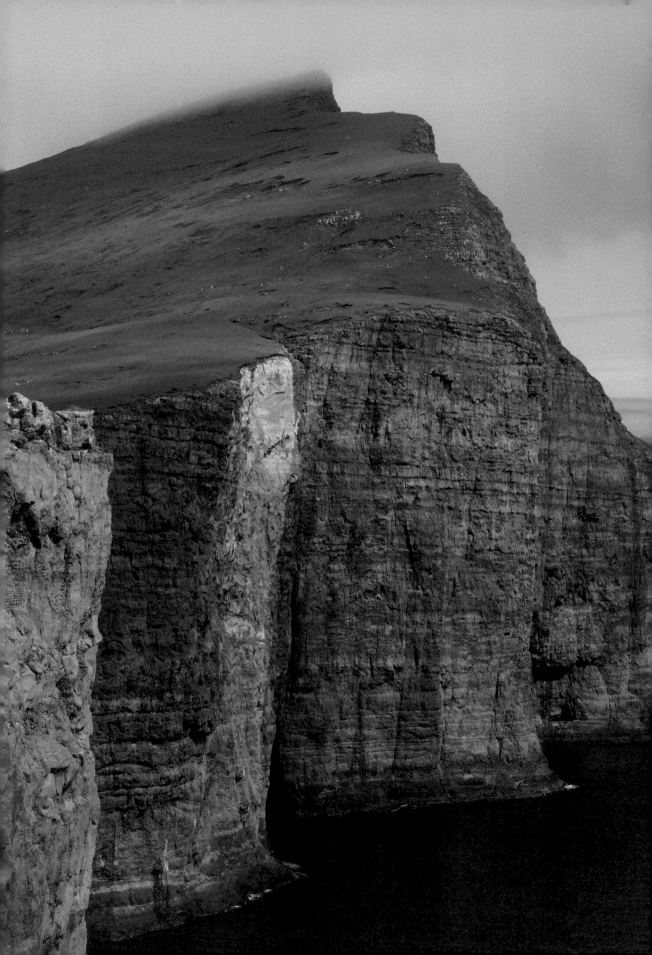

La Gomera, Canary Islands, 2021: A Short Film and Photo Collages

The Canary Islands are close to Africa and far from California and the arid Owens Valley. The cracks of the outcrops of volcanic rocks of La Gomera Island are not discrete. A dense, complex web of fractures looks like a three-dimensional puzzle ready to be tackled. The orange rock pieces are loose, they can be easily removed from the wall of an outcrop like a small bricks without mortar. The volcanic mountains wait for the gravity to be disassembled. Roads are cleared daily from the rocky debris and are often impassable. This experience inspired me to create *The Dam*, a short film about taking apart the mountain with bare hands. La Gomera's fragile cliffs are in fact crumbling when touched, their erosion feeds lavish cloud forests of Laurisilva, a perpetual entropy starts a new life.

During the art residency in La Gomera, I also started large photographic collages, a series titled *Subcritical*. What do we see staring inside the fissures in the rocks? Geologists staring inside tiny gaps can see the past and predict the future. In the *Subcritical* collages, I digitally moved photographed rock puzzles around, the negative spaces replaced by the images of the outer space. This is the ultimate sublime, both the secret and the revelation of life, here in the cracks we see the stars and galaxies.

Faroe Islands, 2022: Animated Film

The Faroe Islands are 50-million-year-old enormous slabs of basalt, with spectacular cliffs carpeted by thick green meadows, shrouded in clouds. With their outer space ambience, suspended in time, these islands feel isolated in the northern Atlantic. This is where I found a protagonist for the *Subcritical* film, a basalt wall along the road to Tjørnuvík on the island of Streymoy. The wall is marked by singular vertical drilling line, a rare human mark on the islands inhabited by more sheep than people.

Subcritical is a short film about Planet B, the planetary geology and a colonization of the universe, it is about Elon and Jeff in space-cowboy uniforms and about landing on the moon. What inspired me to make this film were research presentations of planetary geologists, subcritical cracking of our planet as a symbol of our anxieties over its future, and dreams about the escape to the new earth with the soundtrack of Apollo 11 landing on the Moon. *Subcritical* the film is a fifteen-minute loop of destruction and creation, a cycle with us, or without us. The lights of the stars seen in the crevasses are immune to our concerns.

From initial research to project development, most creatives follow a personal pattern of artistic processes, relying on familiar concepts, often limited by well-established perceptions and craft. It is difficult to escape such processes once guidelines and ways of working have been established. New critical thinking requires opening silos, maybe returning to Goethe's freedom, a premodern synergy of arts and science. We need to wander through the mountains as poets, playwrights, scientists, artists, novelists, all at once, creating new paths of understanding and relating to our planet.

In reconnecting the disciplines, we creatives and scientists can be more effective in combating societal challenges and justifying our work. In many ways, we are all seeking universal meanings and significance, hoping that the vanity of self-fulfillment is overshadowed by a larger purpose. I believe that for society at large, any progress of humanity is measured by the growing understanding of the world and our ability to relate to it emotionally or emphatically.

In my dreams, I still see my Karkonosze frozen in time, forever unchangeable.

Artist Marek Ranis
Title *Subcritical* series
Year 2022-2023 Medium Digital collage, transfer print on aluminum
Dimensions 48" × 64"

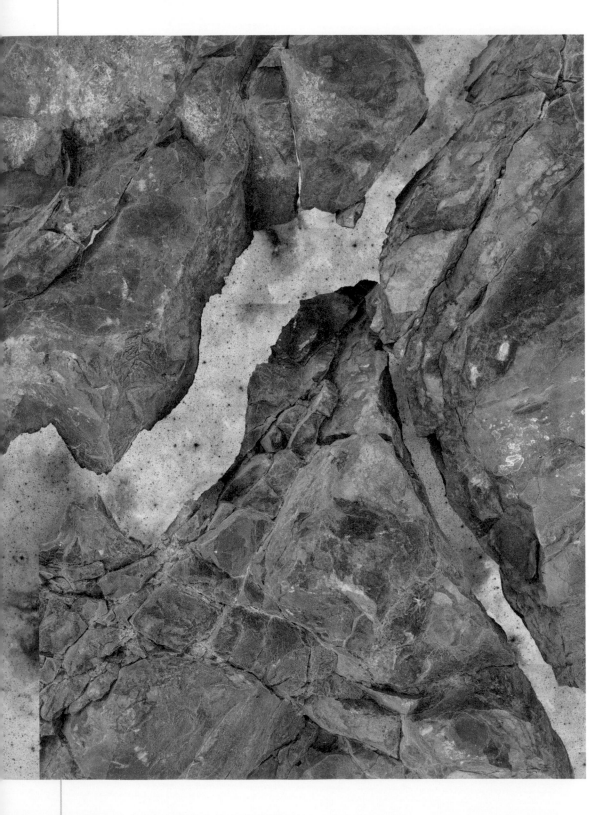

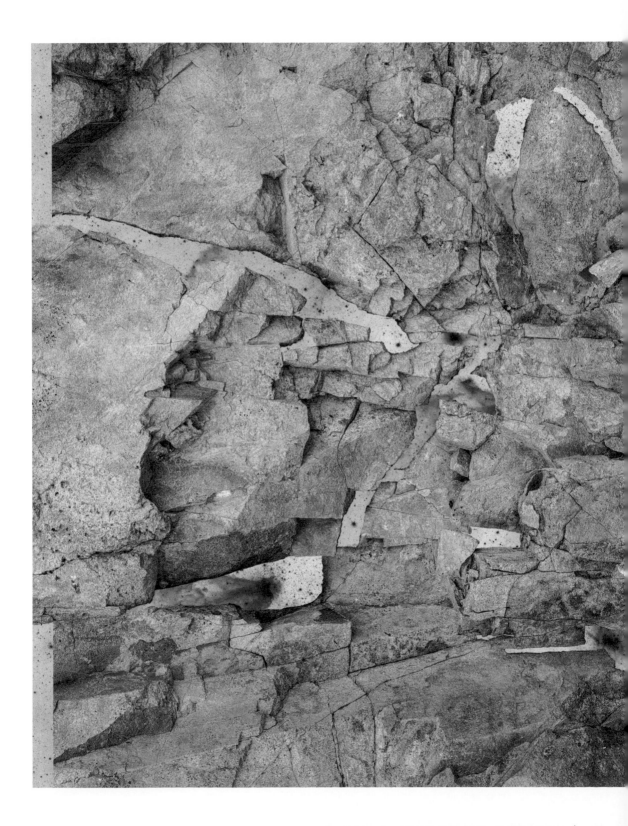

Artist Marek Ranis

Title *Subcritical* series

Year 2022-2023 Medium Digital collage, transfer print on aluminum

Dimensions 48" × 64"

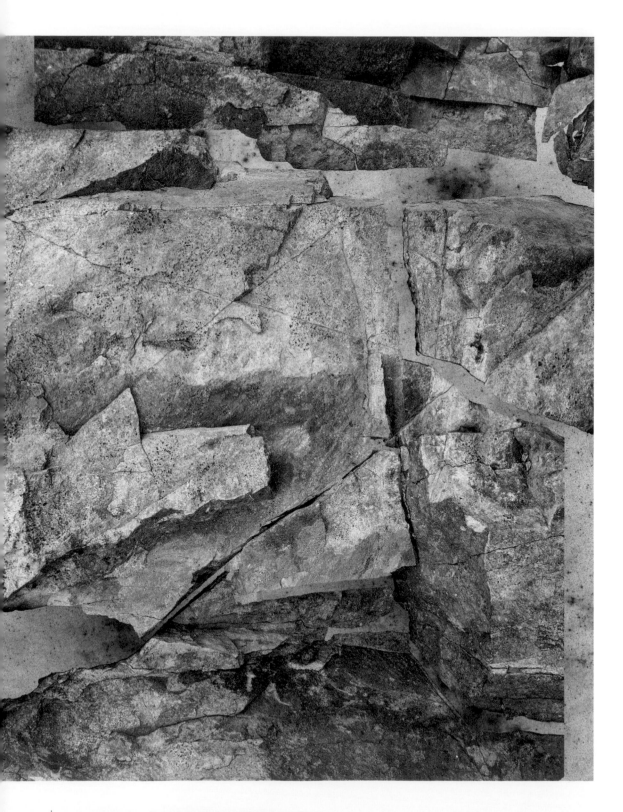

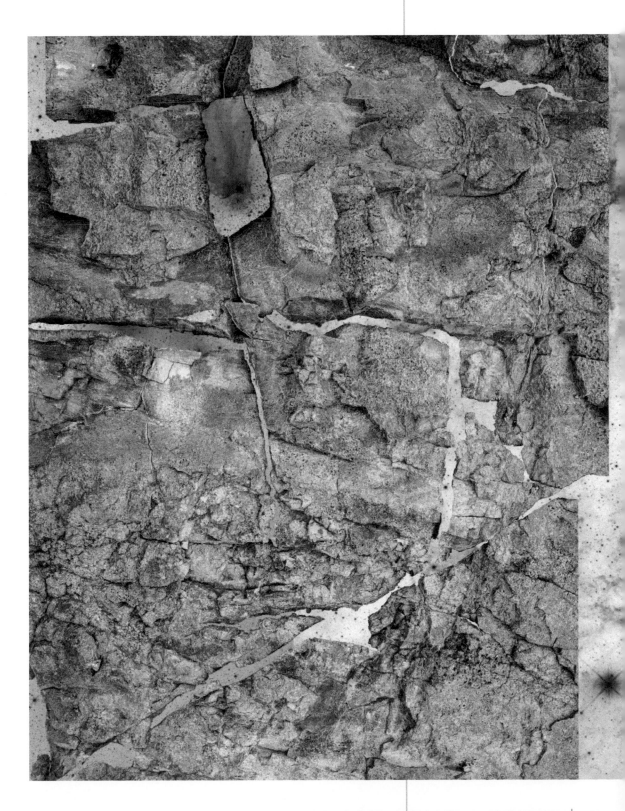

Artist Marek Ranis

Title *Subcritical* series

Year 2022-2023 Medium Digital collage, transfer print on aluminum

Dimensions 48" × 64"

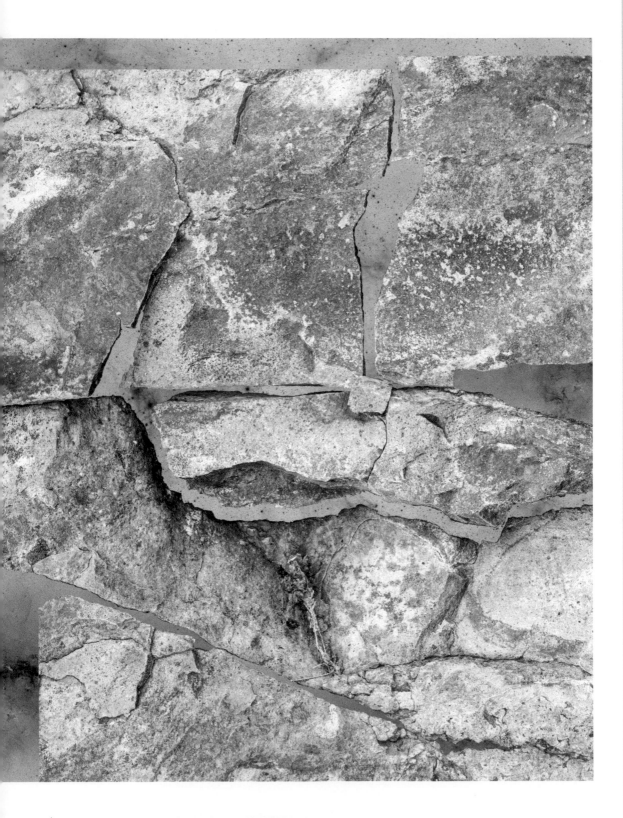

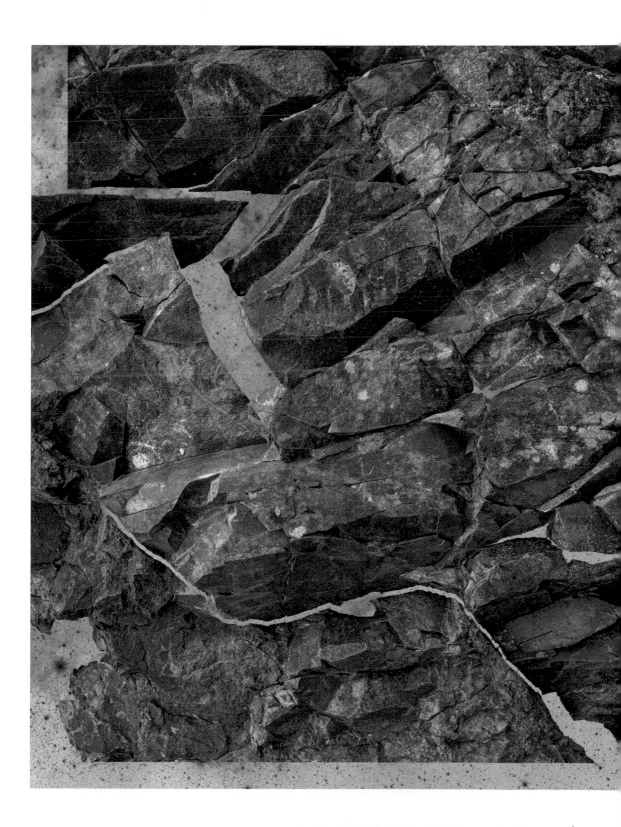

Artist Marek Ranis
Title *Liminal Landscape* series
Year 2020 Medium Mixed media on linen
Dimensions Various sizes

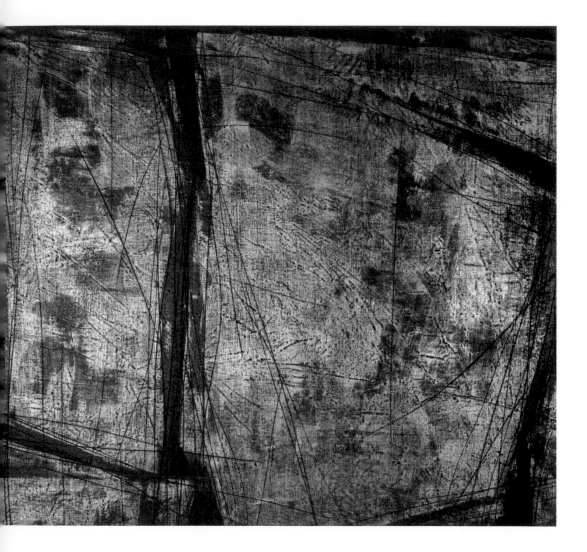

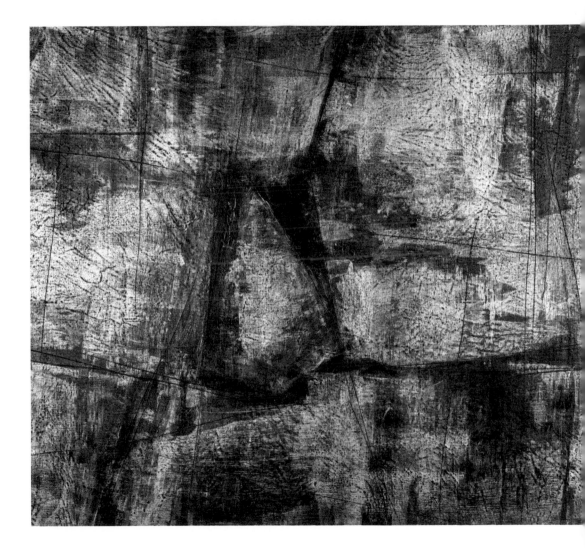

Artist Marek Ranis
Title *Liminal Landscape* series
Year 2020 Medium Mixed media on linen
Dimensions Various sizes

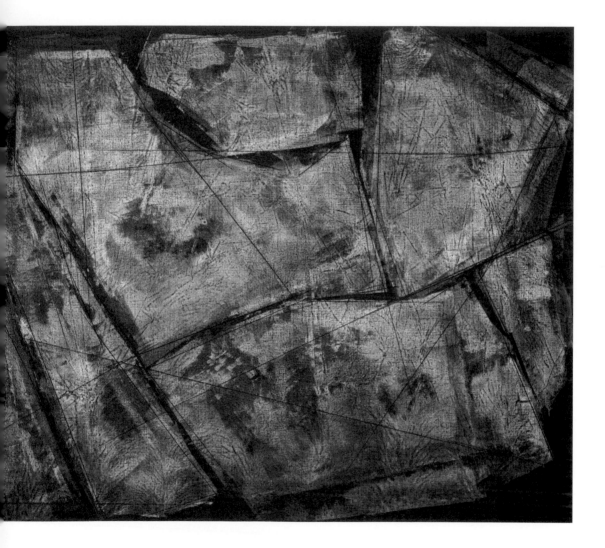

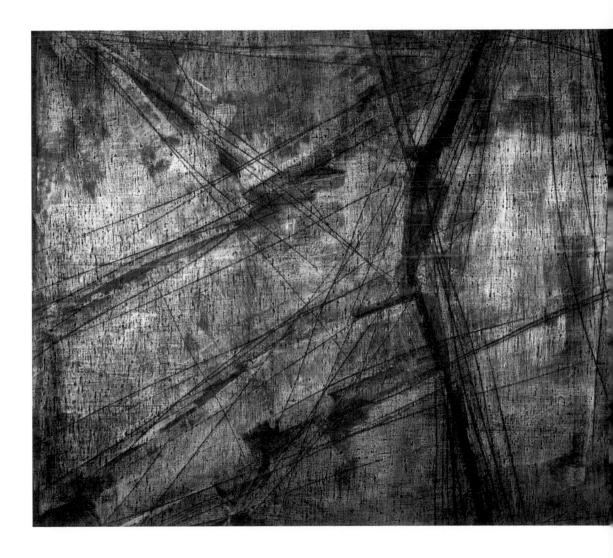

Artist ___Marek Ranis_____

Title ___*Subcritical*_____

Year ___2023_____ Medium ___4K video, 14 min. 24 sec._____

Dimensions _Video still_____

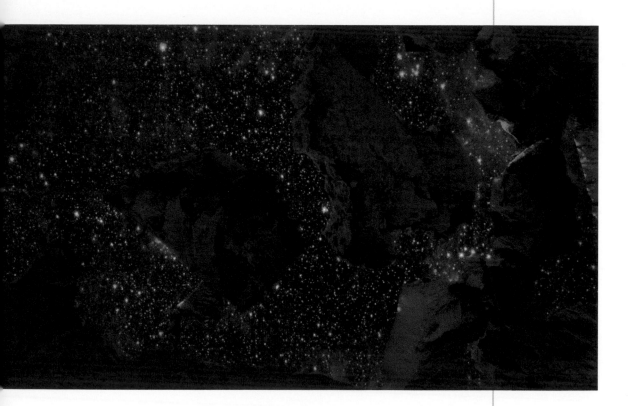

Artist Marek Ranis
Title *The Dam*
Year 2022 Medium High-definition video, 14 min. 24 sec.
Dimensions Video still

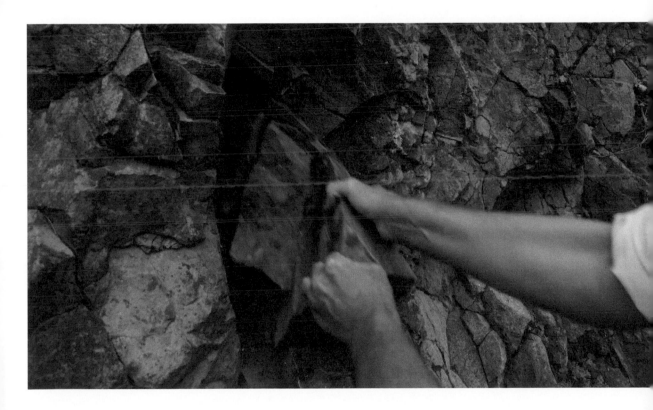

With Your Nose on the Rock, It's All You Can See

By *Monica Rasmussen, PhD Candidate, Department of Geography and Earth Sciences, UNC Charlotte*

My PhD research involves searching for and measuring the length of small cracks in rocks. Sometimes, they are very small cracks – the size of cracks most people would never notice without a magnifying lens, which I used frequently in the field to assess whether a crack was, in fact, a crack. This was the frame of mind I was in when, mere minutes from reaching my field site along with my advisor Dr. Missy Eppes and fellow students, Marek Ranis stopped the van we were riding in. Just next to the road was a boulder as big as the van itself with a crack through the middle that had fully split the rock in two. Marek wanted a photograph. My first thought was, "That's not one of *my* cracks! That's just two rocks! Let's get on to the good stuff!"

Flash forward a year to the Mojave Desert, where Missy and I were discussing an exciting upcoming conference and the variety of disciplines covered by the sessions. We were amazed at the scope of topics and giddy to discuss our study with the various experts who would be in attendance. We couldn't wait to share our own theories and hear about all the new big ideas being generated in our field. Meanwhile, Marek was fretting over the font on the conference flier.

Geologists thrive on disorder and unknowns. We have trained ourselves to welcome the uncertainty, the billions of years of Earth's evolution proceeding so slowly that most changes will never be observed. As we try to place our work into the greater scientific opus, we wonder: Which aspects of the natural world are even *comprehensible* to humans? How has the mathematical order in the natural world fed into our deeply human ability to recognize patterns?

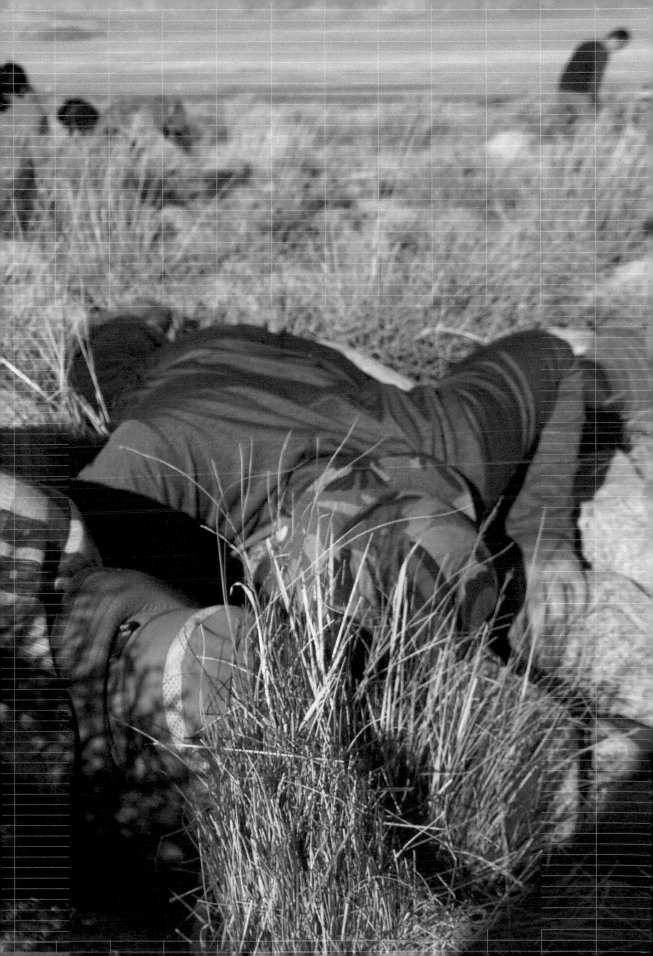

We see rocks as breathtaking puzzles and break our bodies in the field to reach them, measure them, draw them in our field notebooks. Scientific interpretation is the geologist's artform, and every rock is unique and exciting. Two large boulders may look identical, but their material properties tell a different story. Cut those boulders into 1,000 pieces and you'll have 1,000 different stories. Cut those pieces into 50,000,000 pieces and you'll find even more variability. The same measurements on the same rock at different scales will provide a whole range of answers. This doesn't make each one less special or valid. It's just the way the natural world works.

This variability of nature can be uncomfortable. Scientists "can't agree on the science" because there is not one answer. It's one thing to say that we cannot know the exact solution, in other words, "the answer lies between 10 and 12." It's a completely different thing to say, "*the answer is all numbers between 10 and 12.*" Most people think science provides answers, that those answers are definite, finite. If there's anything every earth scientist will agree on, it's that part of the beauty of the Earth is her unpredictability.

Humans think on timescales of hundreds or thousands of years while geology has operated for billions of years. This staggering concept may be the most fundamental change in mindset that comes with being a geologist. It makes our problems feel small and temporary, all a part of something so much bigger that we barely even exist. Working with an artist-in-residence has helped me understand how this deeper, more fundamental, chaotic beauty can be shared with the masses. In return, I hope we bring to artists the perspective of deep time.

In the beginning stages of my PhD, when explaining to fellow scientists how little we know about the slow weathering process of rocks in nature, I could easily see the value of my work. Yet after months in harsh environments,

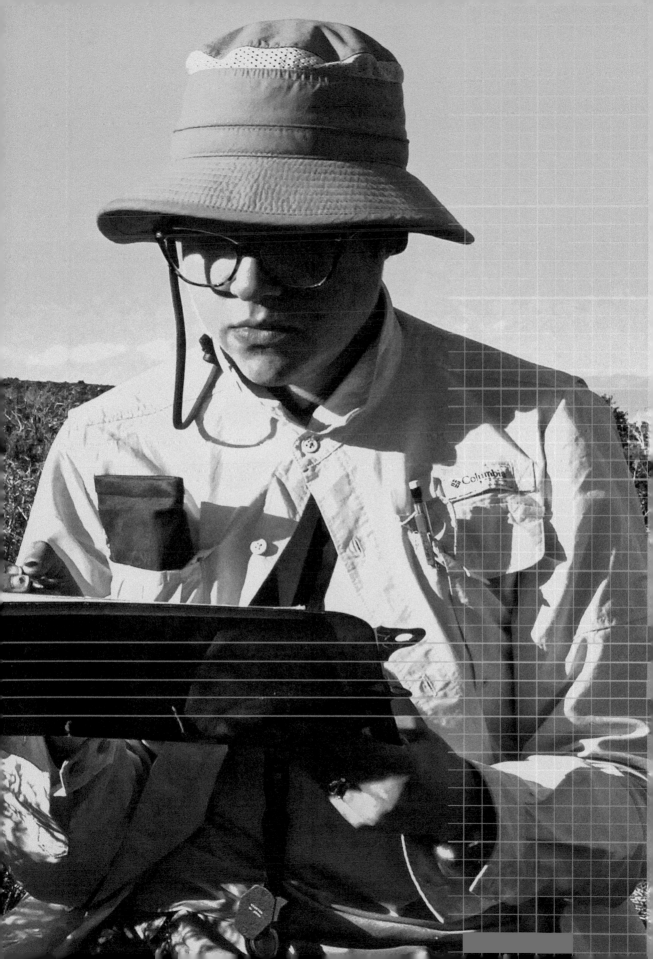

off-grid and dirty, digging car tires out of sand, laying on the ground alongside cacti and velvet ants, hammering and hauling and generally feeling defeated, it's difficult to see the forest for the trees. Fieldwork is often tedious and specialized, and those months are as much of a mental marathon as a physical one. We tend to focus on getting through each field campaign, each round of data entry, each conference abstract submission. This grueling aspect of fieldwork should feel relatable for any graduate student.

We have a lot to think about when preparing to head out into the field. We need to check and pack all equipment, figure out how the trip will be financed, acquire permits, travel to the site, and buy all the supplies necessary to live and work in nature every day. Having Marek around was an unusual addition. When Missy told me that we would have an artist-in-residence for this project, I was excited to see the art produced out of the concepts in my work. I had not anticipated our interactions, and how much his outside perspective would enhance my research and experience.

Marek sees our work for the science, but also for the process – the tedium as meditation, each crack a part of a larger story, and that story intimately linked with the human experience. Instead of emotionally giving in to the physical isolation, working with an artist has brought a new feeling of connectedness to my work. I speak fondly of this experience to my fellow graduate students who can oftentimes only imagine how inspiring it must be to work alongside an artist while doing science.

Marek shows the public how geology is the underpinning of everything – we literally build our lives on top of rocks. Even further, the connections run deep between the rocks under our feet and the plants we eat, air we breathe, and water we drink. We rely on the constant cycling of water, nutrients, fresh rock, new spaces being created within them. I am studying the mechanisms and rates of how rocks naturally

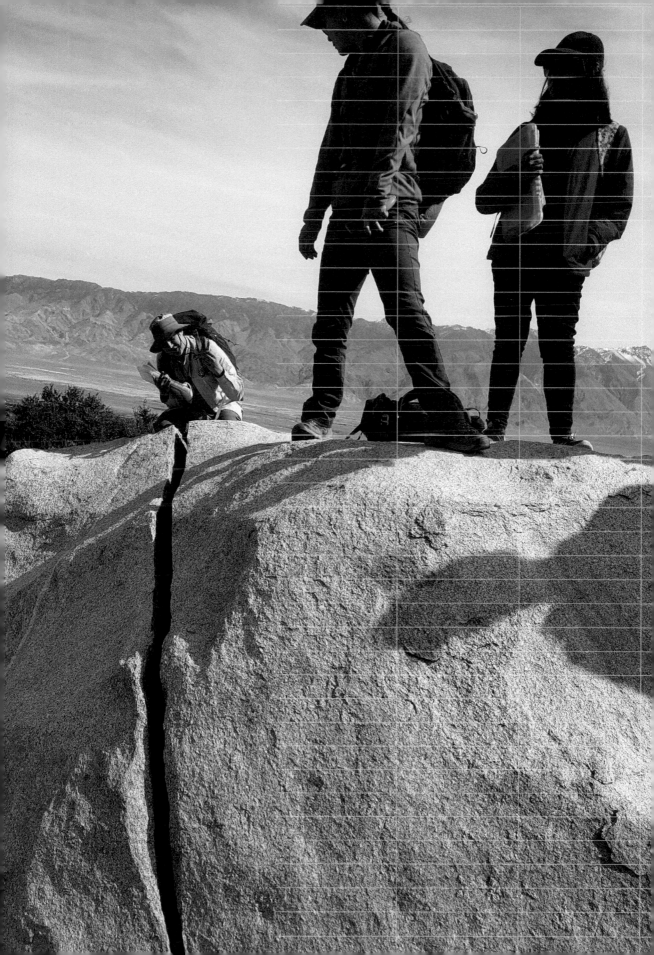

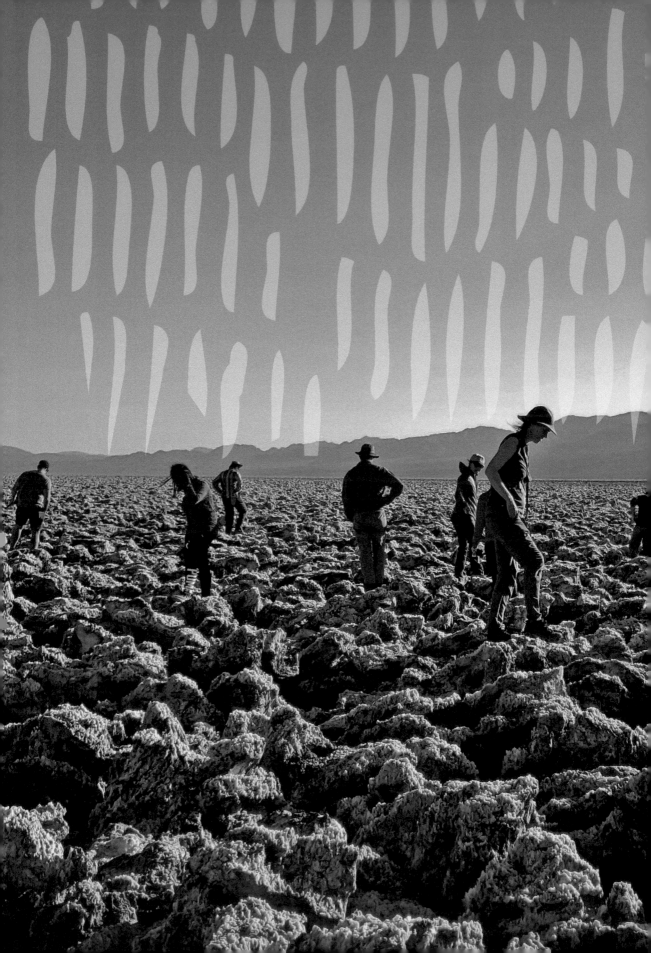

crack, and this slow but persistent breakdown of rock is as much a part of human life as the water cycle. Without it, our world wouldn't exist. Fortunately for me, we know very little about this process, so we have a lot to discover.

I am mathematical, ordered, precise. I try to be a skeptical scientist about my own work, removing my emotional reactions from the analytical process. But I do love art. Putting emotion *back into* geology as a separate but useful tool has been extremely rewarding. It's good to be reminded that a crack the size of a van is still a crack, and sometimes the font on the conference flier does matter.

Rocks can preserve the oldest aspects of human culture directly through carvings and paintings; but their existence itself is tied into our experience. Some rocks give themselves to us, dividing rapidly to provide nutrients and soil, while others stand strong on the landscape, serving as sacred markers like Uluru and Khuwalung, or remind us of our own transience like Stonehenge and the Sphynx. These cultural, artistic, human perspectives have focused my concepts on shorter and shorter timescales, trying to understand not just the behavior and mechanics behind rock cracking, but where this may be happening now, and what it could mean for the preservation of our way of life – and our cultural markers.

Marek spent weeks with us in the field and in the laboratory, observed as we painstakingly documented cracks on thousands of rocks. Seeing my discipline through the eyes of someone with such a different perspective has been both challenging and interesting. Being able to communicate the value and breadth of this work – Marek's vision of the entire universe within the space of a crack – is not only gratifying, but also extremely important for continued public support of the geosciences.

First Steps: *"Capacity, or: The Work of Crackling"*
Making a Dance of Cracks in Parallels
By Melissa Riker, Choreographer, Kinesis Project dance theatre

I am a choreographer and dancer. I approach the world through movement, the body, how bodies interact with – and in – space, and I ask questions that manifest in dancing artwork. Right now, for the foreseeable future, and for the last year, my art practice has been focused on cracking.

In October 2021, I began a new work with the dancers of Kinesis Project. My questions were about cracking, breaking open, and our human capacity for love, grief, and trauma. I wondered if this kinesthetic and emotional experience might be echoed in the physical world, perhaps in rocks. In preparation to guest teach a fourth grade class, I Googled "How do rocks crack?" and found the writings and videos of Dr. Missy Eppes.

I was astounded at the similarities between my imaginings and her studies. So, as any curious person might do, I wrote a note to Dr. Eppes on November 17, 2021:

> "I've just begun the research and creation of a new work I am calling: Capacity/or: The Work of Crackling. It stems from my curiosity of the parallels between the processes you describe and study in the earth – the tiny, time, forces and stresses process of weathering and cracks to questions of how these process will change as climate change continues ... to our human capacity for grief, love, resilience and the way we crack or heal over time – or in the last two years, how cracks occur at a much lower stress level because the entire being is at a certain point of pressure."

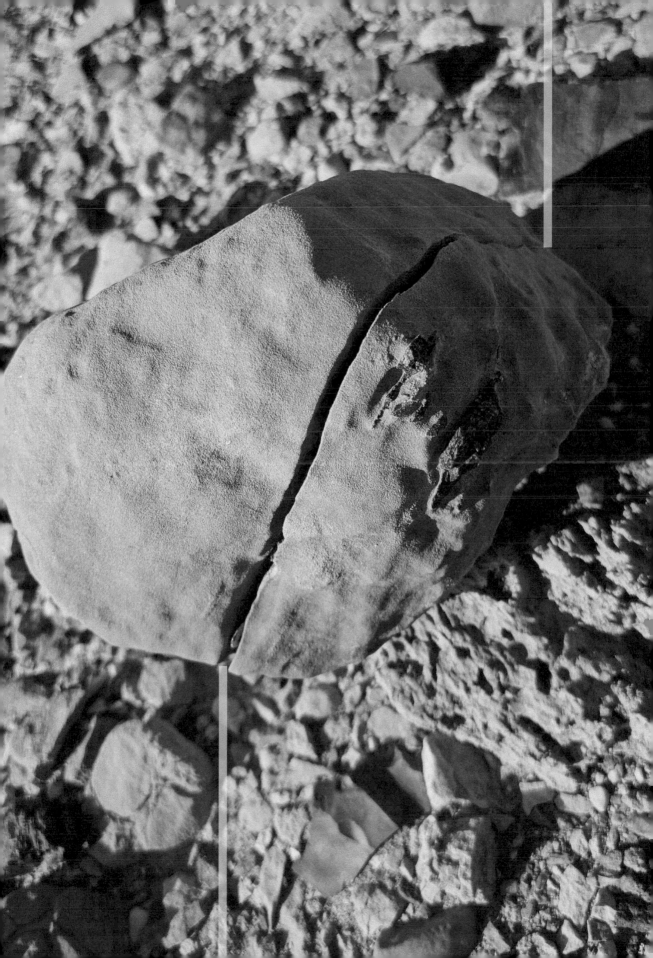

As Dr. Eppes writes:

> "Given sufficient time – and in geology we have plenty of that – cracks will form and propagate under stresses that are much lower (even less than 10%) of the rock's critical strength."

Our phone conversation that same morning was one of comingled amazement and excitement at our overlaps, so much so that Dr. Eppes invited me to apply to be an artist-in-residence for her geological convening, Progressive Failure of Brittle Rocks 2022 (PRF22).

Questions of internal capacity/cracking open had been simmering inside me for a while, but to frame my questions in 2021, please consider what happened to the field of dance following the immediate shutdowns due to COVID-19 in 2020: As our world closed down and the months dragged on, the entire field of dance nearly collapsed. As an art form, it was already precariously positioned – to function, it requires space, community, and physical training, all of which were suddenly deemed illegal and unsafe – and while other closed businesses were given plans for reopening, dance wasn't acknowledged. From March 2020 to May 2021, professional dancers, choreographers, teachers, and workers were left without income and without state or federal relief to survive.

It was time I approached this work that had been simmering in questions of capacity.

I was pushed not only by the dance field's struggle to recover from closure, but also the levels of loss COVID created and how the lives of friends and family were clearly still at stake, even after repeated tragedy fueled the largest social justice movement in history via Black Lives Matter. I felt the resilience of our hearts cracking open yet further to comprehend our collective grief.

Notes After connecting with Dr. Eppes, our creative process grew ...

depends
on the molecules
stuff [clay] → integration
cracks

Dw [illegible] → filling →

Water
Chemical cracking
of ponds → not just
pressure etc →
wears it down → Climate
over all
lessens the coherence

① cracks → filling up w/
chemicals & water
whole thing though
the rock → cracked but solid
open space of the fracture makes
it more susceptible to cracking
the filling up then heals creates
more small fractures & then
stops cracking [because of space]

filling can create More cracking
underground → pressures are
greater

→ Hydration → water table – water
fills all spaces
above water table water is adhering
to rocks → critical source of moisture
for trees during drought →

ter w/ Minerals in soil can "illuviation"
ials

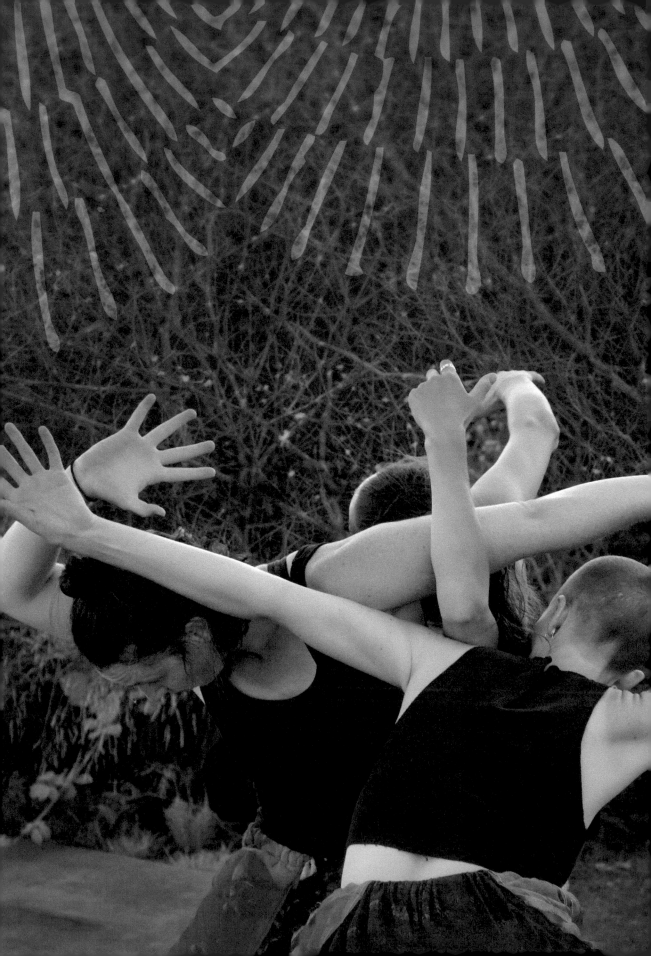

So I began a process that I called *Capacity, or: The Work of Crackling* – stepping into the studio on my own, and then with dancers. Roughly ten days before I reached out to Dr. Eppes, I sent some prompts to the New York City dancers. I was interested in how the experience of cracking also leaves room for water to move differently – thus the discussion of "cracking" and then "flow," or: what changes when more space is offered?

Prior to this, I'd offered the dancers a freewriting prompt of if-or-when they had ever filled something to the point of breaking, or to write about "over-fill":

Warm up thoughts

Give yourselves a "crackling" and "flow in the cracks warm up" – similar to what we did on the rocks in the park. Perhaps, swap off or round-robin to different people's ideas of drying out and cracking open.

As the warm up goes on, let your focus open – when you catch someone else's eye, find a new way to crackle or flow.

"Filling" solo prompts

1. Trade/tell one of the "filling" stories you wrote about last week with one other person.

2. Ask them to pull out three or four elements of your story that seem important to them and share them with you.

3. Take some time to build a short phrase inspired by the other person's story.

4. Build a separate phrase from your own story, leaning on the elements you pull out and that your partner pulled out – let those words or ideas help if you get stuck.

Subject ___ Prompt: "Filling the spaces" ___
___ Kimberly Holloway, Madeline Morser, Alicia Pugh ___
Location ___ Seattle ___ Photographer ___ Briana Jones

It is within this curiosity that *Capacity, or: The Work of Crackling* has developed. In the year and a half since my initial questions, my conversation with Missy, and the time absorbing and sharing information with the scientists of PRF22, our collaborators have come together. The costumes were created by Rebecca Kanach from images of rock textures she found in the Alaska wilderness, and we now work in tandem with Opera on Tap and Anti-Social Music to create and perform the sonic elements of the work. The current version of the piece involves multiple dancers, singers, and instrumentalists, five composers, and three organizations. Demonstrating that, for the performance world, our resilience is our community.

In the audience's program for *Capacity, or: The Work of Crackling*, I provide our audiences with two separate program notes. On the cover, to provide immediate context of the dance, it reads:

> **From the Director**
> *How can I possibly take on more (love, grief, joy, fear ...)?*
> *What are my edges?*
> *How do our cracks appear?*
> *What if breaking creates more space?*
> *How does pressure effect a sense of "cracking"?*
>
> *And ... What if this is similar to how rocks crack?*
>
> *These questions and so many more fill our notebooks. Spoiler alert: how we crack, create space, break apart, self heal, find flow ... are uncannily similar to how the earth does much of the same. From subcritical cracking to fracture events ... geology to mechanical engineering ... the earth to humanity.*

On the inside of the program, I explain more plainly how all of this dancing, singing, music-ing came into being.

Subject Prompt: "Pulling/pull apart"
 Kinesis Project NY, Opera on Tap NY, composer Diana Woolner
Location Inwood Hill Park, New York City Photographer Cristobal Vivar

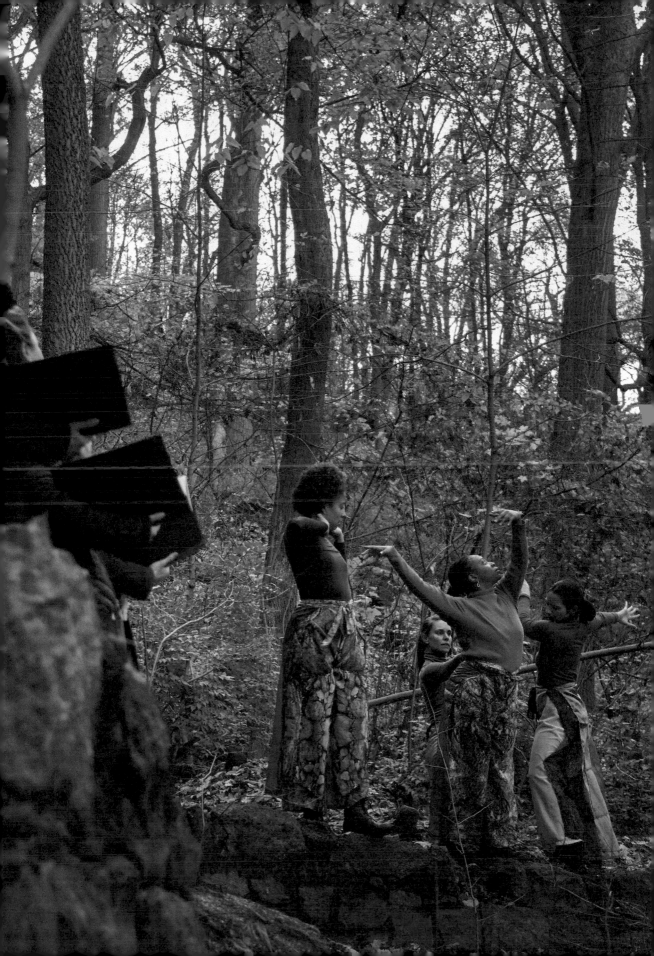

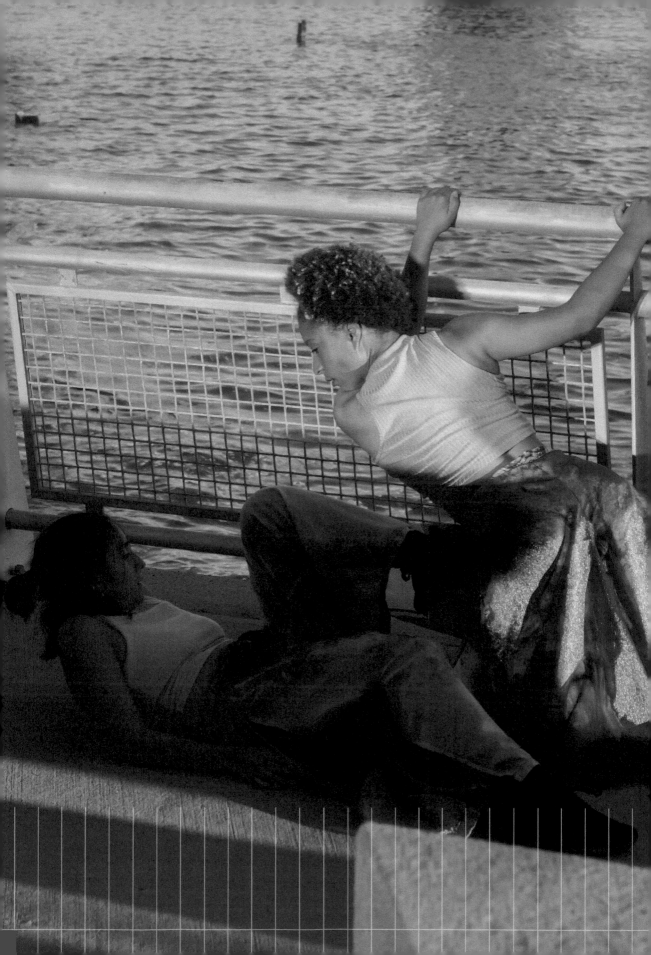

Choreographer's Note

The beginning of this work included falling in love, and then falling in love again – wondering each time how much wider could my heart be? I felt it crack open a little further, and I found more space ...

It also happens to me this way with joy and grief – which made me wonder: is this how I find my resilience? Do others experience this? From conversations with friends I thought it might be true.

Follow a long time later, and add global pandemics causing unimaginable pain, immense grief, and sometimes unusual joyful moments of new connections – and these cracks, these ways of breaking open ... these ways of leaning into community as we could manage – new resilience was discovered, lost, and recovered.

As I sat with these questions, I recognized a new work was brewing. Dancers and I entered a studio with questions about rocks, cracking, flow, and humanity – which led me to research actual geology. Thanks to the internet, I found the amazing Dr. Missy Eppes. Her discoveries about rocks cracking mirrored my questions in an uncanny way. I reached out ... and the rest ... is history. Dr. Eppes and I hit it off with our collaborative questions and I was honored to be the Artist in Residence for her Penrose convening "Progressive Failure of Brittle Rocks 2022" with geologists, geomorphists, mechanical engineers and others who deeply care how rocks crack and our earth changes ...

Spurred from our conversations and with a better idea of what research papers to focus on, prompts were sent to dancers to take research time on their own prior to rehearsal that included links to interviews with Dr. Eppes and her collaborators. In rehearsal, we began tracking

Subject Prompt: "Journey + timeline with rock fitting/negative space"
 Hilary Brown-Istrefi, Sabrina Canas
Location Riverside Park, New York City Photographer Hisae Aihara

and using our environment, a thread of granite in marble became a pathway in a dancer's body – the concepts pulled from Dr. Eppes' research became texture and our questions about "failure" became entire movement thoughts.

The peak of Mount Rainier, the expanse of Puget Sound, the marble markers in Riverside Park, the granite of Manhattan Island, the glacial remains in Inwood Hill Park – all of these are built into our movement vocabularies. Layering these elements with the additional questions including "how do you pack your suitcase?" or "have you ever filled something to the point of breaking?" and finally: "write about a time you went on a very long journey for something very small."

In dance, the time we spend imagining, experimenting with ideas, testing and generating movement, is (also) called research. As you may have already gathered, a creative process is similar to a scientific one. However, we as artists are not asked to prove any one thing; we exist as mirrors, offering all possibilities and ways into information. The collaboration between myself and Dr. Eppes is working exactly this way.

In a span of imaginings-as-research and science-as-research, we are creating a large-scale, outdoor immersive performance of dance and opera. Or as we like to say: "a dance of geological proportions."

All photos of performance in this essay are from Capacity, or: The Work of Crackling, *choreographed and directed by Melissa Riker and created in collaboration with Opera on Tap, Anti Social Music and Dr. Martha Cary (Missy) Eppes.*

Subject Prompt: "Bridge mineral + sound + time," Sabrina Canas, Hilary Brown-Istrefi, Madeline Hoak, Breeanah Breeden, composer Eyal Moaz
Location Riverside Park, New York City Photographer Hisae Aihara

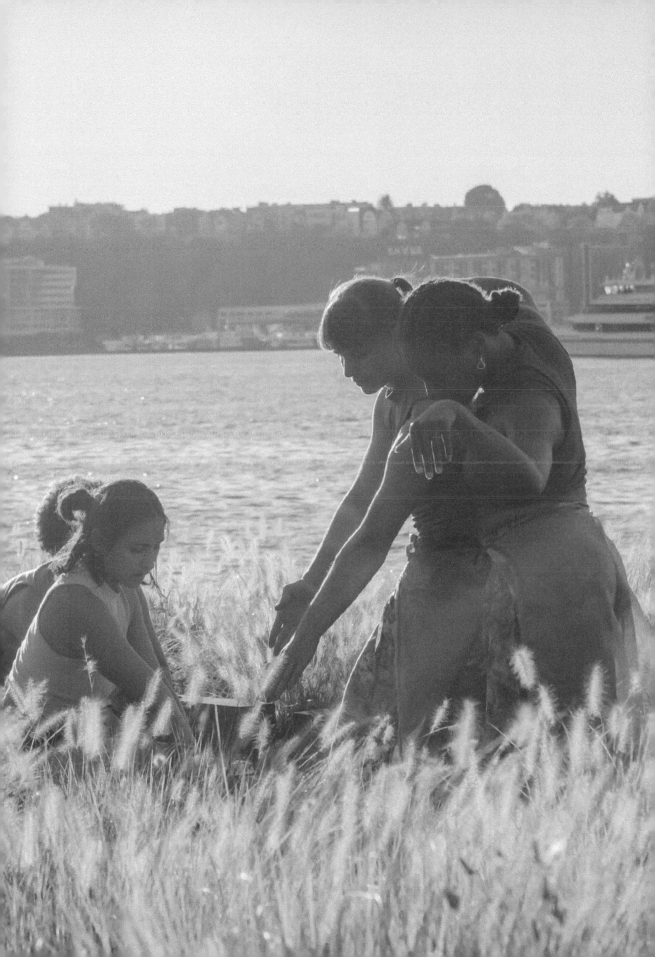

Subject Prompt: "Fitting in spaces + journey"
 Margaret Behm, Hendri Walujo
Location Expedia Beach, Seattle Photographer Briana Jones

I am fascinated with how the care demonstrated between the dancers is much like the caught rock formations in one of our performance spaces, Inwood Hill Park.

Subject Glacial rock formations in Inwoord Hill Park, New York City
Photographer Melissa Riker

Subject Prompt: "Bridge mineral + sound + time," Sabrina Canas, Hilary
Brown-Istrefi, Madeline Hoak, Breeanah Breeden, composer Eyal Moaz
Location Riverside Park, New York City Photographer Effy Grey

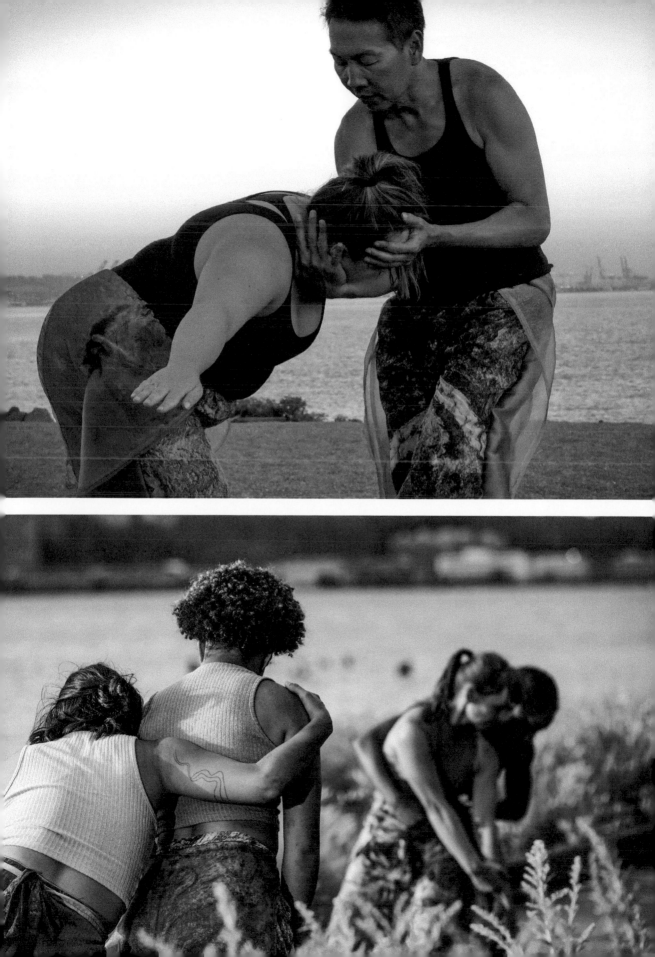

Subject Prompt: "Lean back-to-back – stay aware of what shifts"
Hendri Walujo, Madeline Morser, Margaret Behm, Kimberly Holloway, Alicia Pugh
Location Expedia Beach, Seattle Photographer Briana Jones

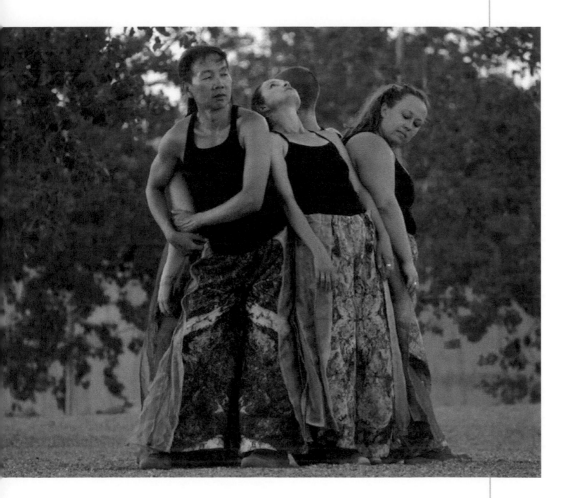

This is affectionately called "the boulder." Dancers walk backward
from a long distance to find one another's backs, leaning, using
pressure to stay standing, physically listening, and responding to
any shift that may happen in the group.

Subject Prompt: "Lean back-to-back as a group, listening, move toward the ground (and back up)," Breeanah Breeden, Hilary Brown-Istrefi, Madeline Hoak, Sabrina Canas
Location Riverside Park, New York City Photographer Hisea Aihara

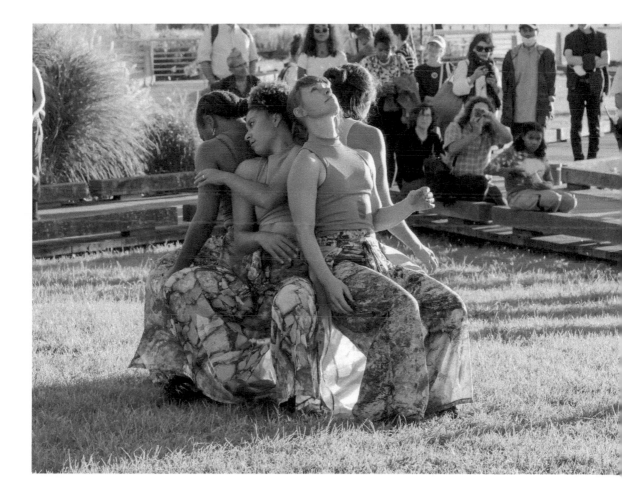

On the last day of PRF22, I did a performance. The beginning of the performance was the scientists receiving various prompts for conversation or action. I invited duos of scientists to lean back-to-back, essentially dancing and weight-sharing to create movement models.

Subject Prompt: "Pulling/pulled apart + flow in the spaces"
 Alicia Pugh
Location Louisa Boren Overlook, Seattle Photographer Briana Jones

This image by Briana Jones of Alicia Pugh echoes one prompt I gave the PRF22 scientists: "What is your bridge mineral?"

Subject Prompt: "Sound + tracing the quartz in a marble block"
 Hilary Brown-Istrefi
Location Riverside Park, New York City Photographer Effy Grey

During the process, Hilary Brown asked: "Scientists monitor rocks closely and use the data they discover. How do we monitor ourselves? What do we do with the data we learn?" This question became the center of a section of the work.

In addition to "What is your bridge material," these are three questions given to the participants of PRF22. A month later, I brought them into the rehearsal process as well.

Have you ever filled something to the point of breaking?

How do you persist?

Do you believe in failure?

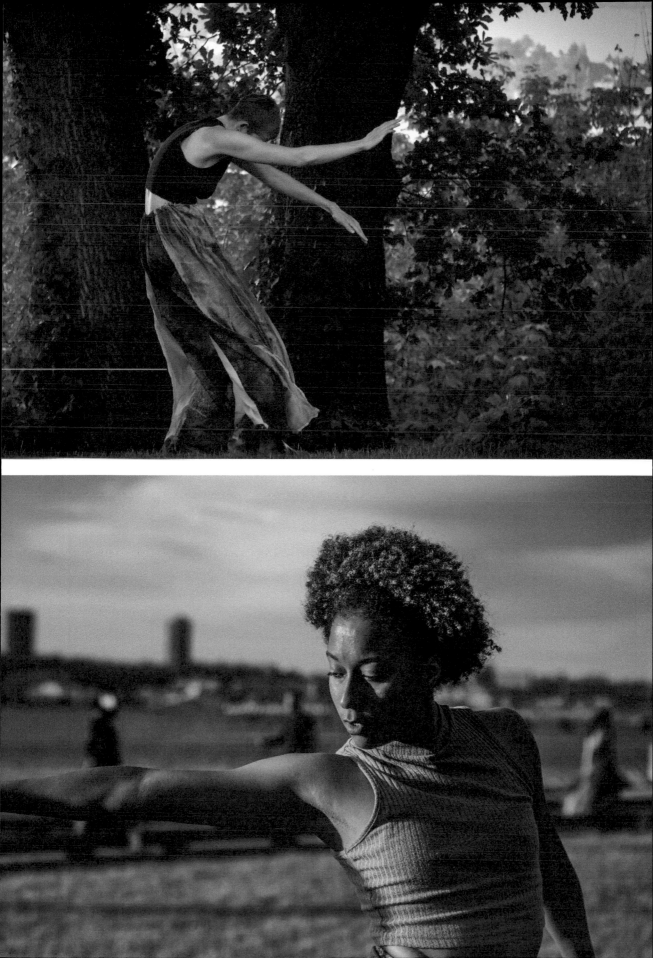

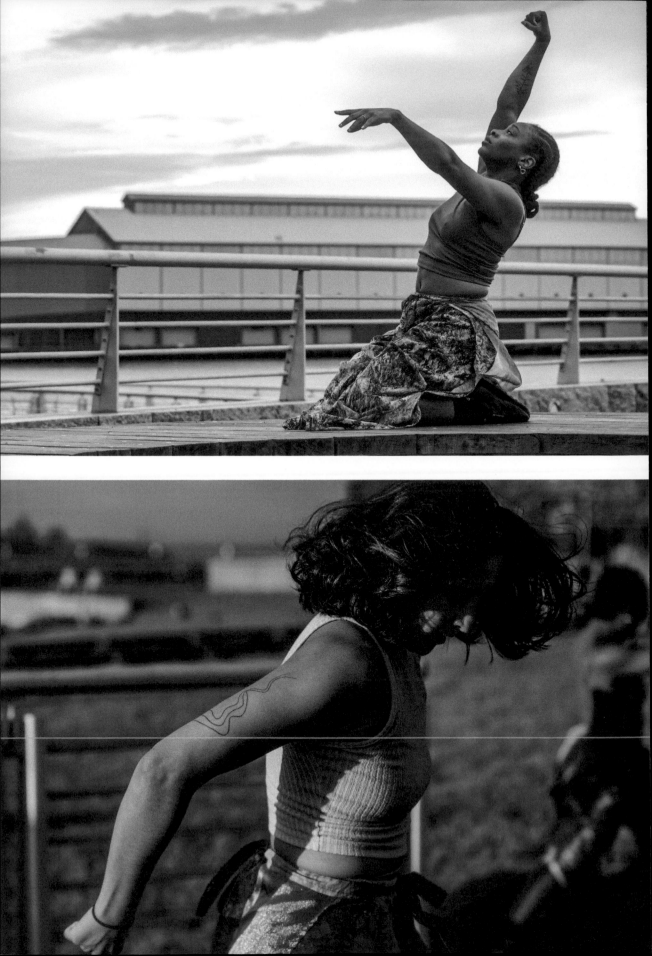

Subject Prompt: "Do you believe in failure?"
 Bree Breeden
Location Riverside Park, New York City Photographer Effy Grey

Subject Prompt: "Sound + mapping quartz in marble" – also reads like "How do
you persist?" Sabrina Canas
Location Riverside Park, New York City Photographer Effy Grey

Notes drawing the position of dancers and musicians for Brian McCorkle's "Subcritical Cracking," a section of music using Dr. Eppes words as the libretto.

We continue forward, observing, asking questions, and considering the parallels. Our ability to crack, expand, and continue is resilience. Simultaneously, we understand that as humans, we too will experience a critical fracture at a surprising moment if we have been under intense outside pressures. This opens a route for dialog and conversation about care for one another in a direct link to the studies of our earth via our own humanity.

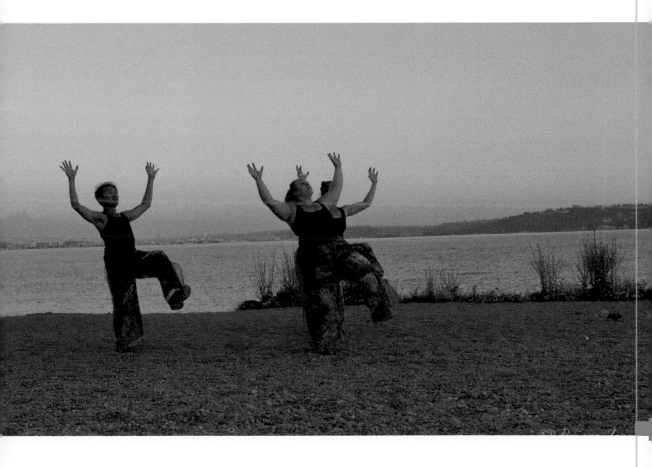

Subject Prompt: "A trio based on the essence of one dancer's movement inspired by sounds," Hendri Walujo, Margaret Behm, Kimberly Holloway
Location Expedia Beach, Seattle Photographer Briana Jones

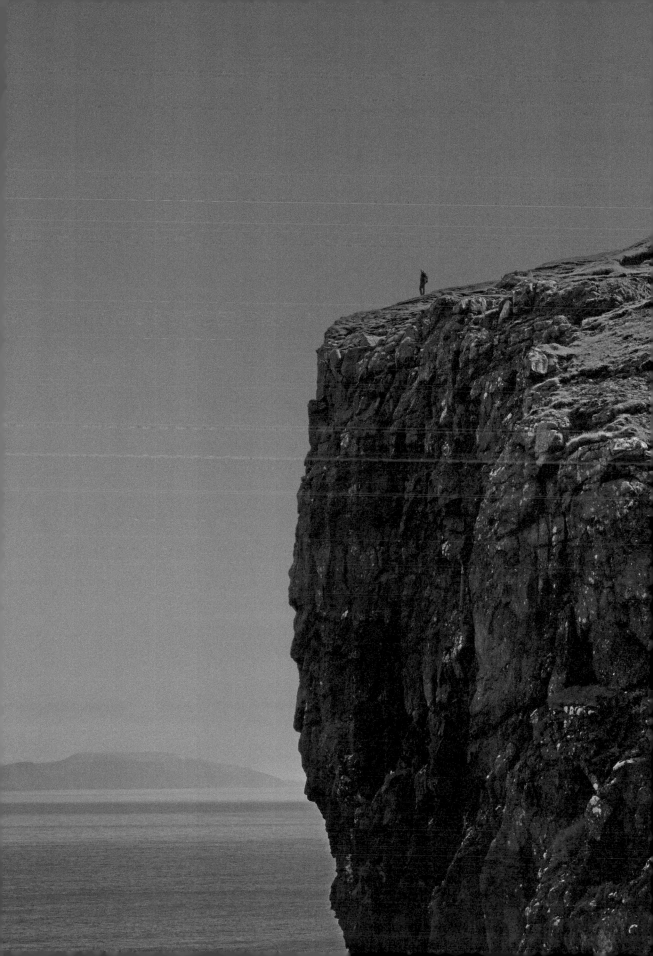

Geology for Artists, Art for Geologists

By *Ken Lambla, Former Dean of the College of Arts + Architecture, UNC Charlotte*

While *positivism* is often construed to imply that assertions are limited to that which results from empirical scientific evidence, usually in controlled experiments and statistical analysis, it also carries the belief that assertions depend on that which we can observe. *Observation*, then, becomes the unifying force bringing the artist and scientist together.

As former dean of the College of Arts + Architecture, I was able to nurture and exhibit cultural phenomenon that eschewed the separation between disciplines. Around 2010, the college embarked on an annual exhibition platform titled "Keeping Watch," focusing on environmental challenges surrounding Mecklenburg County, North Carolina. Four years focused on distinct themes: plastics (solids), creeks (water), air quality (gas), and habitat (shelter). Both Marek Ranis and Missy Eppes participated in these exhibitions as artist and observer.

With Dr. Eppes receiving a National Science Foundation (NSF) grant for her ongoing work on geological fracturing, she approached the College of Arts + Architecture to develop a partnership within this grant to fund an artist residency in field research, lab processing, and scientific evaluation over multiple years of work with geologists around the world. The goal was a *partnership* that relied equally on the role of *observation* to evoke scientific and artistic understandings of the processes in earth science.

Working with college faculty in all disciplines (architecture, art, art history, dance, music, and theatre), a Request for Proposals was crafted to encourage the development of existing lines of work and stimulate new partnerships. Importantly, two external reviewers agreed to evaluate the

proposals: Professor C. Soriano, associate provost for Arts and Interdisciplinary Initiatives, Wake Forest University; and Professor T. Stanley, chair, Department of Fine Arts, Winthrop University. Both reviewers had experience in collaborative projects; Soriano in the fields of dance and neuropsychology in aging populations, and Stanley in cross-cultural installation art. Professor Ranis was chosen, in part, for his extensive ongoing work in sculpture, videography, painting, and photography based on climate change in extreme cold environments. He was also engaged due to his dedication to the role of art/science partnerships avoiding the pitfall of the artist-as-illustrator.

Both Ranis and I began to participate in classroom activities with Dr. Eppes, as well as field work in the Owens Valley of California, observing measuring methods and devices used as part of the empirical work of geologists. This close observation helps develop the "working knowledge" (Douglas Harper) necessary to communicate across artistic and scientific realms. I believe such partnerships can only flourish with time and an acute ear/eye commitment. Spending eight-to-ten hours in the sun looking at rocks together "locks in" common vision, inquiry, methodological comparison, and dialogue that promotes both scientific and artistic processes. It was the common *rigor* that joined artist and scientist together.

Neither Eppes nor Ranis had a predetermined outcome; this is sometimes hard to explain in a grant application. Eppes had been working in both the field and laboratories around the globe for years with a speculative eye on how rocks crack. Ranis has lived and worked in residence in Alaska, Norway, Iceland, Greenland, South Africa, and other locations. Ranis sought not to draw pictures of rocks; Eppes sought to avoid visual translation of scientific method. Through their interaction a *mutuality* evolved, the "each" replaced with the "two" as in "two sides of the same coin." This requires both respect and a willingness to be wrong; and for both to rely on the other's disciplinary approaches.

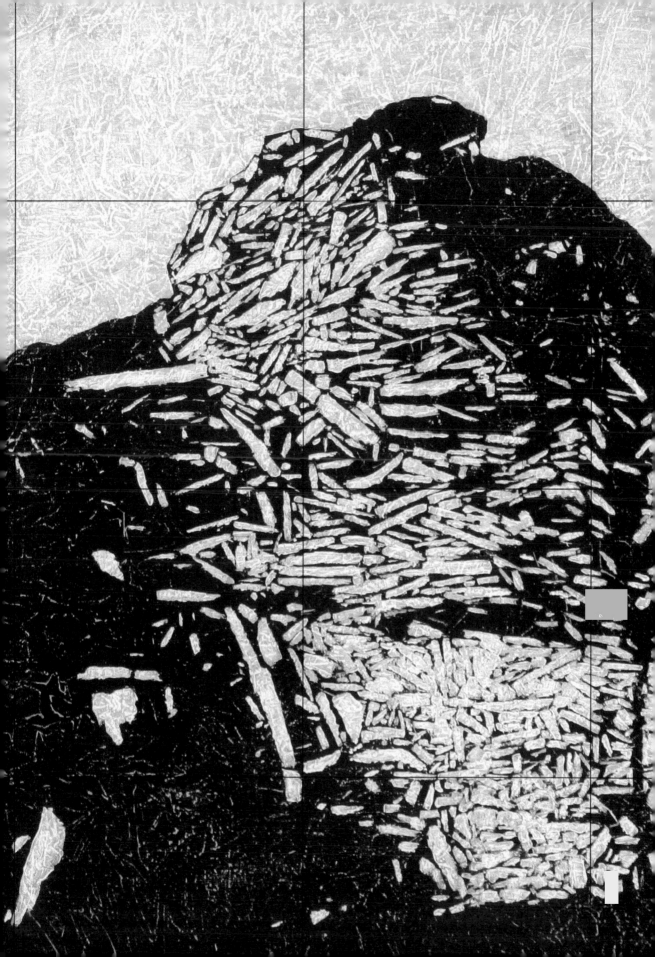

It is never perfect. But the long-standing separation of Art and Science is now being confronted more commonly in both scientific and artistic practices. Within the disciplines of arts and design, collaborative effort has become expected, with grant institutions and peer-review processes recognizing crossovers. Dr. Eppes's partnership with Professor Ranis is but one illustration of how both practitioners can flourish together.

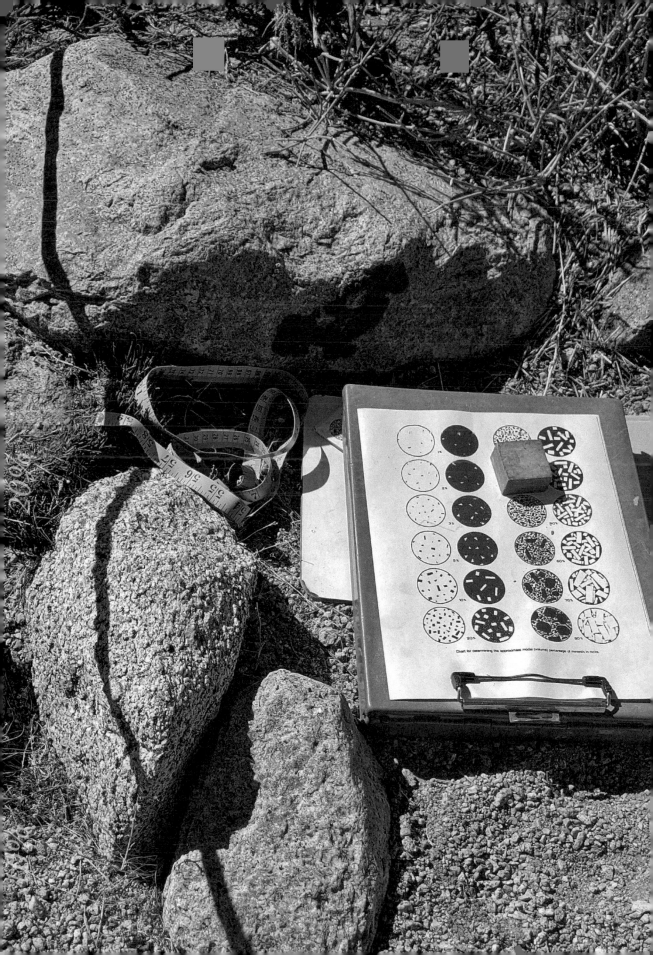

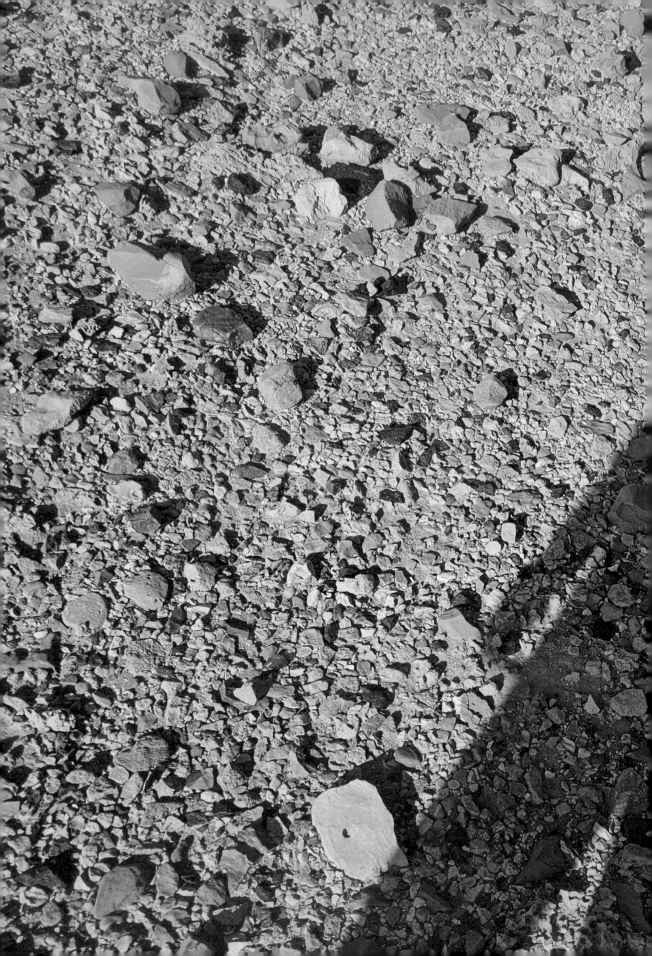

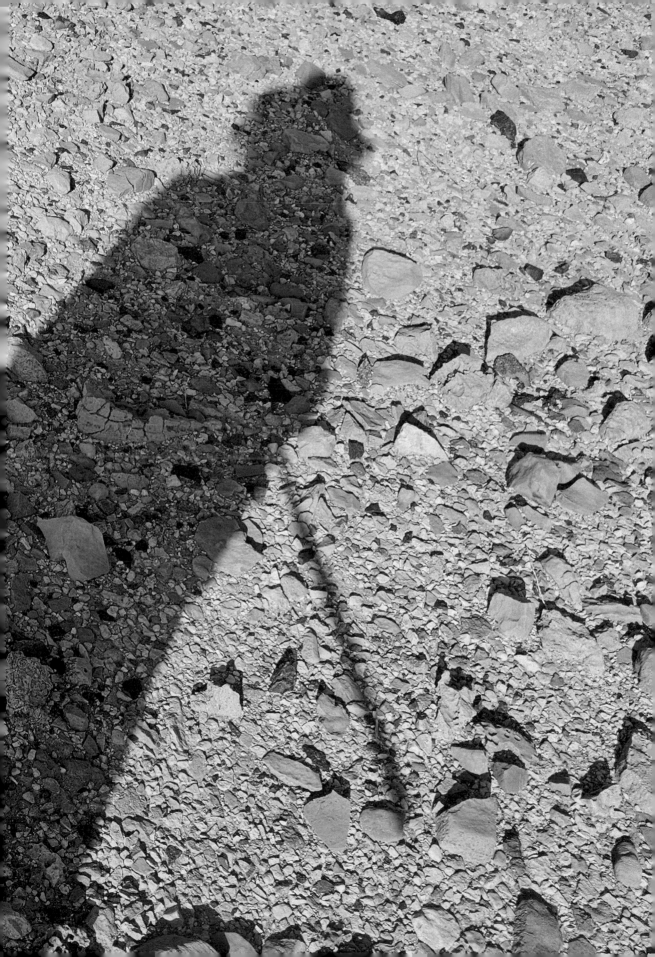

Acknowledgments

There are many people who deserve recognition for their support of and inspiration for this project, some of whom have contributed to this book, but we also acknowledge the many Native groups upon whose unceded land the work (both artistic and scientific) has taken place and who now share it for our enjoyment, curiosity, and livelihoods.

We would also like to thank the Geological Society of America (GSA) for featuring the work of Dr. Eppes and Professor Ranis in a noontime panel presentation at the GSA annual meeting held in Portland, Oregon, in October 2020. We would also like to thank the GSA for allowing us to share the recording of that panel presentation, which can be found here: https://gsa. confex.com/gsa/2021AM/webprogram/Session50812.html.

For those scientists who are curious about Dr. Eppes's scholarly publications, an example essay titled "Rates of Subcritical Cracking and Long-Term Rock Erosion" can be found here: https://doi.org/10.1130/G45256.1. Again, our thanks to the GSA for allowing us to share this publication.

There are also many individuals, agencies, and organizations who have supported this team's work over the years. This material is based on work supported by the National Science Foundation under Grant Nos. 1744864 and 1839148. Our colleagues at UNC Charlotte's Atkins Library, in particular Savannah Lake and Ryan Miller, provided critical editorial and graphic design expertise that enabled us to take an idea and bring it to fruition in the form of this book. The team at UNC Press also provided critical support through editorial guidance as well as through their Thomas W. Ross Fund Publishing Grant, which gave this project a much-needed boost. UNC Charlotte's College of Arts + Architecture and College of Liberal Arts and Sciences also provided support that helped bring this project to the finish line.

Lastly, Missy Eppes and Melissa Riker have many more thanks to offer and those are best captured in their own unique voices:

Missy Eppes: *I would like to thank the myriad students who have inspired me to think more deeply about science, my own research, and how I communicate it to them and the rest of the world. I would like to acknowledge the connection*

to art instilled in me by my mother Frankie Norris Eppes and my sister Elizabeth McCall Eppes, the former for insisting that there is time and space for beauty in every time and every space, and the latter for always sharing with me the inner workings of art and the professional life of artists. Finally, I thank Ken Lambla for translating my whim into the amazing reality of building knowledge through fine art, and especially for identifying Marek as the perfect complement to the effort.

Melissa Riker: Capacity, or: the Work of Crackling *was directed and choreographed by Melissa Riker/Kinesis Project dance theatre, created in collaboration with Dr. Martha Cary (Missy) Eppes, Opera on Tap, and Anti-Social Music. Some of this work is featured in this book, and it was made possible with financial support from Summer on the Hudson/Riverside Park Conservancy, John C. Robinson, public funds from the New York State Council on the Arts, a state agency, The Howard Gilman Foundation through The Upper Manhattan Empowerment Zone, The Bowick Family Foundation, NYC Uptown Parks, and individual donors of Opera on Tap and Kinesis Project dance theatre.*

We acknowledge the composers Diana Woolner, Brian McCorkle, Eyal Moaz, and David Friend. The incredible performers of this live, ephemeral work are: Kinesis Project NY dancers: Hilary Brown-Istrefi, Madeline Hoak, bree breeden, Sabrina Canas; Kinesis Project Seattle dancers: Hendri Walujo, Kimberly Holloway, Margaret Behm, Madeline Morser, Alicia Pugh, Robbie Moore; Opera On Tap singers: Shawn Farrar, Brittany Fowler, Ilana Goldberg, Rachel Hutchins, Bryan Murray, Kayleigh Butcher, Blake Burroughs, Kannan Vasudevan; Anti-Social Music instrumentalists: Jeanne Velonis, Jeff Hudgins, Johnna Wu, Eyal Moaz, Abby Swidler, Dan Pearson.

Art takes community and creating as a community builds our resilience.

Contributors

Martha Cary (Missy) Eppes, PhD, is a professor of earth sciences at UNC Charlotte. Her research interests center on natural rock fracture, soils, and landscape evolution on Earth and other planetary bodies. Dr. Eppes is a fellow of the Geological Society of America (GSA) and a US Fulbright Research Scholar. She is a recipient of GSA's Kirk Bryan award – their highest honor awarded for quaternary geology and geomorphology – and the American Geophysical Union Earth and Planetary Surface Processes group's Marguerite T. Williams Award given for her "groundbreaking, interdisciplinary research linking rock fracture mechanics and surface processes."

José L. S. Gámez, PhD, is the interim dean of the College of Arts + Architecture at UNC Charlotte. He was previously the associate dean for research and graduate programs in the College of Arts + Architecture. He has served as the interim director of the School of Architecture, as the associate director of the school, as a provost faculty fellow, as well as a research fellow with both UNC Charlotte's Institute for Social Capital and Urban Institute. His research explores questions of culture in architecture and urbanism through action-based research and public scholarship.

Ken Lambla, fellow of the American Institute of Architects, MArch, is a professor emeritus and founding dean of the College of Arts + Architecture at UNC Charlotte, where he has been on the faculty since 1983. His career in both education and practice is focused on architecture and the arts as forms of community development and advocates social responsibility, craft, and innovation. In February 2021, Lambla was elevated to the American Institute of Architects College of Fellows, the organization's highest membership honor. The AIA recognized Lambla for "advancing the standards of architectural education, training, and practice."

Brook Muller, MArch, is the Charles Eliot Chair in Ecological Planning, Policy and Design at the College of the Atlantic, previously serving as the dean of the College of Arts + Architecture at UNC Charlotte. After earning a master's of architecture from the University of Oregon, he worked with Behnisch and Partners Architects in Stuttgart, Germany, serving as project co-leader on the design of the IBN Dutch Institute for Forestry and Nature Research, a European Union pilot project for sustainable design. Muller is author of *Blue*

Architecture: Water, Design, and Environmental Futures (University of Texas Press, 2022).

Marek Ranis, MFA, is a professor in the Department of Art and Art History at UNC Charlotte and a multimedia environmental artist. Through sculpture, installation, painting, photography, and video, Ranis explores social, political, and anthropological aspects of phenomena such as climate change. He is a recipient of numerous grants, fellowships, and residencies, including a UNESCO Aschberg Fellowship, American-Scandinavian Foundation Grant, and NC Artist Fellowship Award. Ranis has presented work in more than a hundred individual and group shows nationally and internationally. His work is included in private and public collections in North America and Europe.

Monica Rasmussen is a PhD candidate in the Department of Geography and Earth Sciences at UNC Charlotte, where she is studying the mechanical weathering of rocks on Earth's surface. Monica is a geologist who spent approximately ten years working in the geosciences industry prior to starting her PhD. She is a recipient of the Geological Society of America Quaternary Geology and Geomorphology Division's J. Hoover Mackin Award, a top honor for PhD candidates awarded by the Society. Dr. Eppes is her advisor; they met at a bar in Antarctica on Christmas Eve.

Melissa Riker, BFA, is the artistic director and choreographer of Kinesis Project dance theatre. She is a dancer and choreographer who emerged as a strong creative voice in the New York City performance world. Riker is the executive producer of the EstroGenius Festival, founder and co-director of Women in Motion, and founder and collective member of Dance Rising. Riker's dances and aesthetic layer her training in ballet, modern dance, martial arts, theatre, and circus. She invents large-scale outdoor performances and spontaneous moments of dance for public spaces.